First Printing, 2015
ISBN-13: 978-973-0-19085-4

A collection by Alexandru Ciobanu
alexandru.ciobanu.books@gmail.com

From the series Photographic Tours.

www.alexandru-ciobanu.com *www.alexandruciobanubooks.wordpress.com*

ROME

A PHOTOGRAPHIC TOUR

122 AMAZING PHOTOS

ALEXANDRU CIOBANU

2015

PREFACE

Rome was the center of the world for centuries. Even today, it still is the heart of the Roman Catholic world. Rome is one of the most visited cities on the planet, which doesn't come as a surprise if one thinks about its rich historical, cultural and artistic life.

The old and the new, history and modernity, go hand in hand on the narrow streets and large boulevards of Rome. Architectural wonders flood the visitor's eye, and the archaeological artifacts of ancient Rome satisfy the search for history. Visitors can relax in beautiful squares and find peace of mind in quiet churches where famous painters and sculptors worked centuries ago. The traveler can also happily indulge in the delicious Italian cuisine in restaurants found all over the place, completing the culinary experience with a delightful ice cream near the Trevi Fountain.

Not many cities around the world are as photogenic as Rome. Photographers, painters, and filmmakers have always found this city attractive due to its visual appeal and romantic atmosphere. The present book gathers an impressive collection of photographs that portray beautiful Rome from different perspectives. We hope this visual journey will please both the nostalgic tourist returning from his trip and the prospective traveler planning to visit the city of Rome.

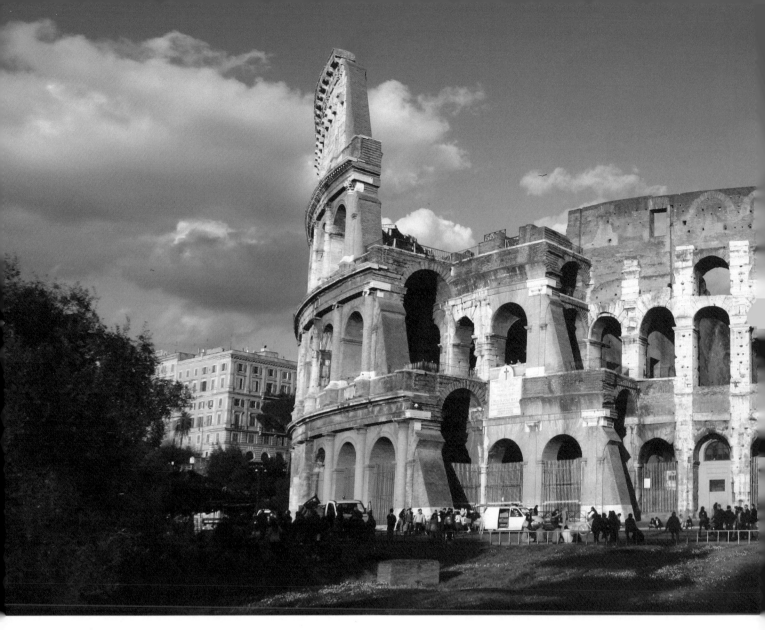

The best-known ancient monument in Rome is, without any doubt, the Colosseum (Colosseo) also known as the Flavian Amphitheater. Finished in 80 A.D., it was the largest building of this type in the Roman Empire, and it still holds the record for the largest amphitheater in the world (photo 1).

The Colosseum had eighty arches on each floor (photo 2). This magnificent construction was the showcase for gladiator fights and other spectacles like dramas based on mythology, animal hunts, or even executions.

Next to the Colosseum, is the Arch of Constantine (Arco di Costantino, photo 3) dating from 315 A.D. It has a height of 21 meters/68.89 feet, and carvings and statues richly decorate it.

The fascist dictator Benito Mussolini built the Via dei Fori Imperiali road. This impressive boulevard links the Colosseum with the Roman Forum and Piazza Venezia (photo 4).

The Roman Forum (Foro Romano) is a site rich in historical artifacts and buildings (photo 5) from the Roman Empire.

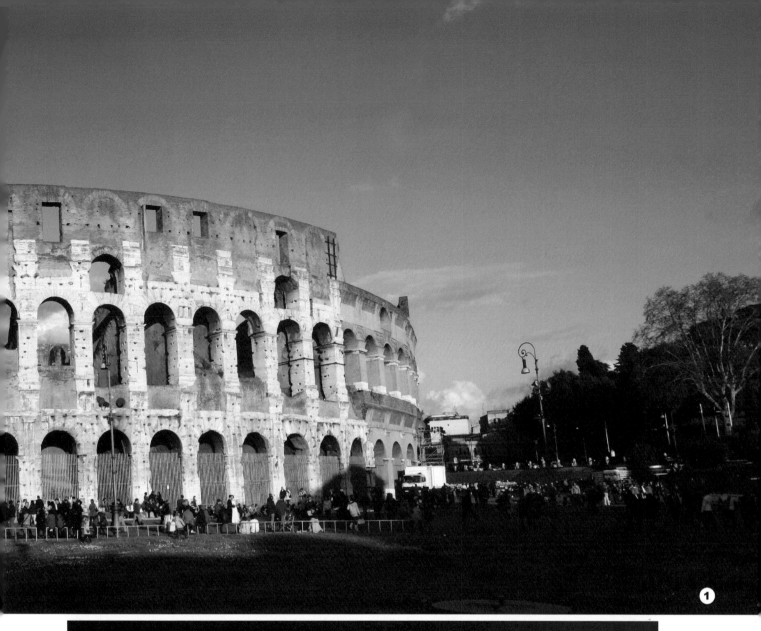

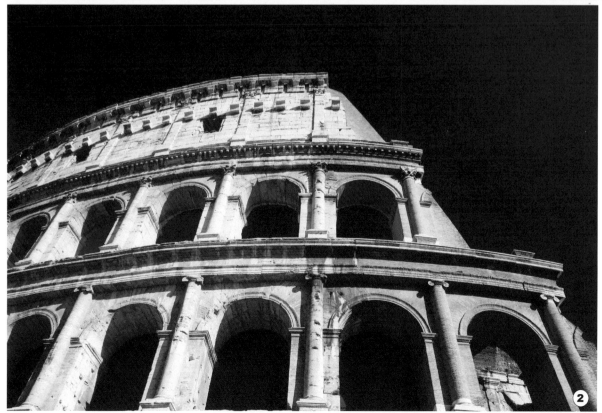

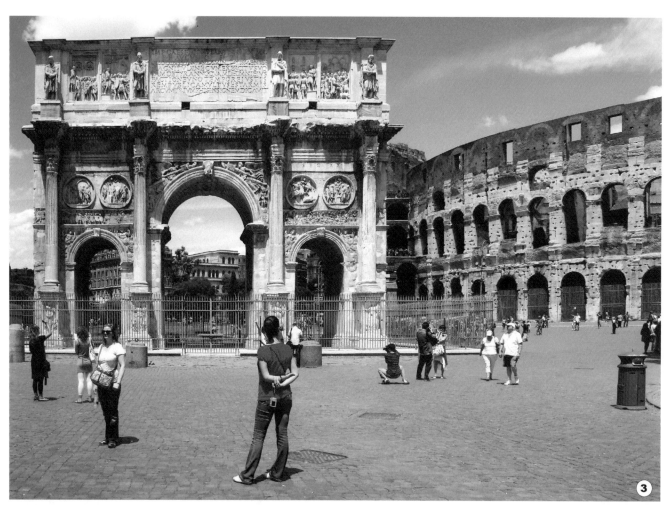

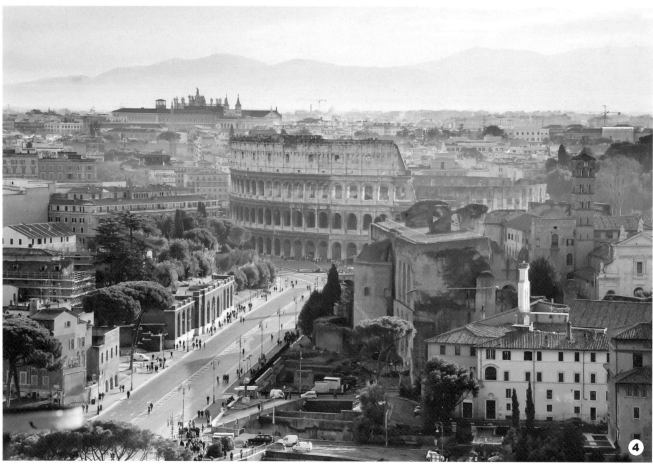

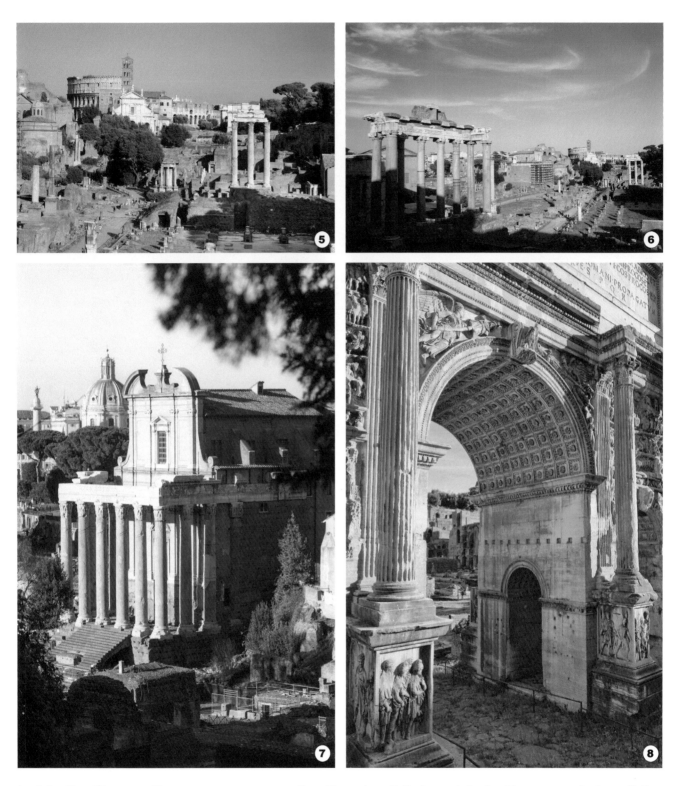

Inside the Roman Forum one can see the Temple of Saturn (photo 6), a remainder of the grandiose ancient Rome.

Other beautifully preserved monuments are the Temple of Antoninus and Faustina, dating from 141 A.D. (photo 7), the Arch of Septimus Severus (Arco di Settimio Severo, photo 8) or the House of the Vestal Virgins (Atrium Vestae), with the statues of the priestesses of Vesta, goddess of the hearth, family, and home (photo 9).

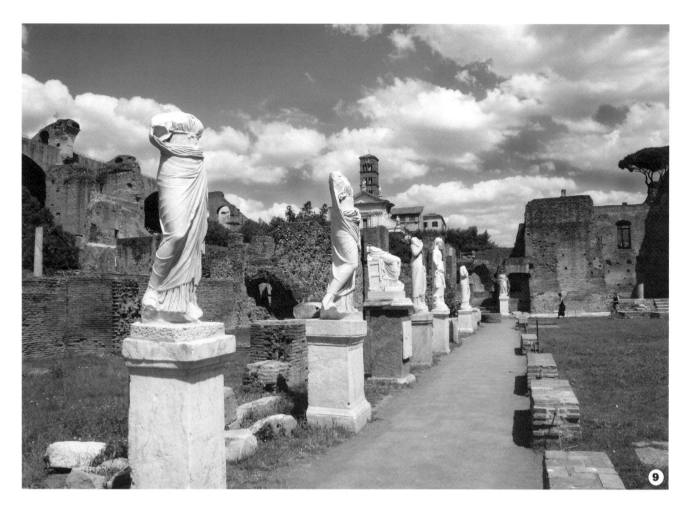

The Trajan markets are part of the Trajan Forum, another ancient architectural complex built between 107 and 113 A.D (photo 10).

Also found here, the Column of Trajan (Colonna Traiana) is an impressive monument (42 meters/137.8 feet high) located next to an old church, the ancient Basilica Ulpia (photo 11).

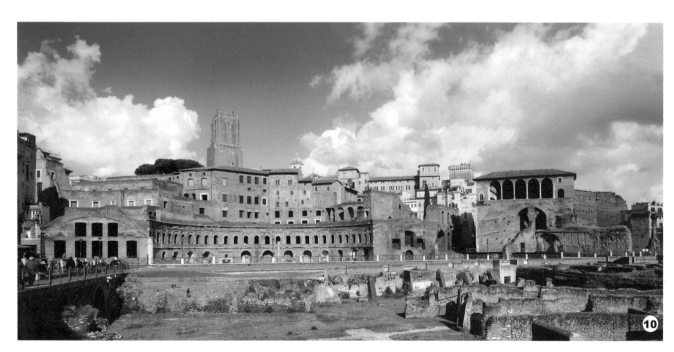

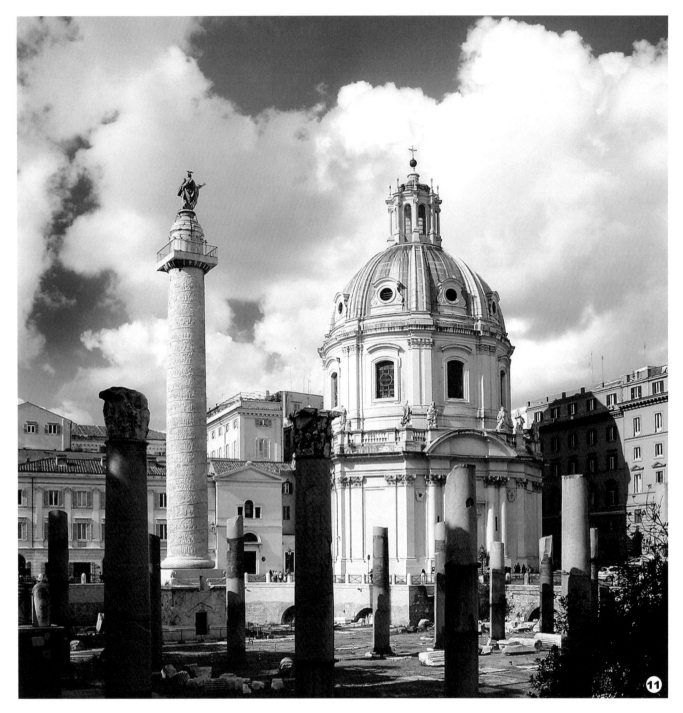

The details from the Column of Trajan (photo 12) depict scenes from the war between Trajan's army and the Dacians, inhabitants of Dacia (present-day Romania).

Close to the Column there is also the statue of Trajan, the emperor of the Roman Empire between 98 and 117 A.D. (photo 13).

The magnificent Piazza Venezia is within walking distance from the Colosseum. This is where visitors can see the impressive National Monument of Victor Emmanuel II, also known as "Il Vittorino" (photo 14).

Here, one can also admire the Generali Palace (Palazzo Generali) (photo 15).

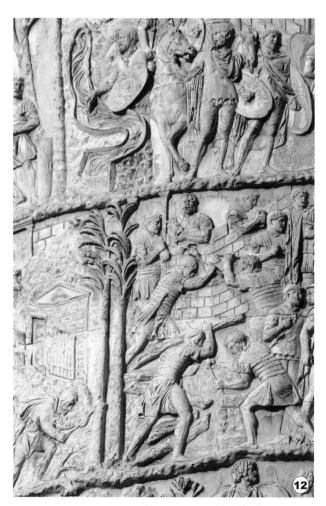

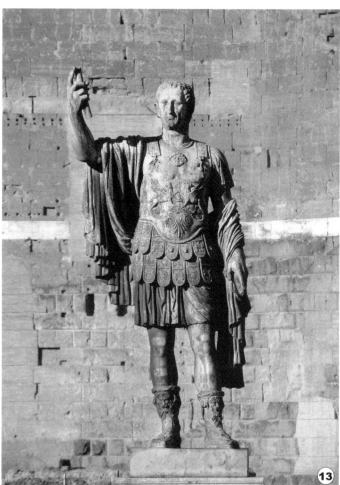

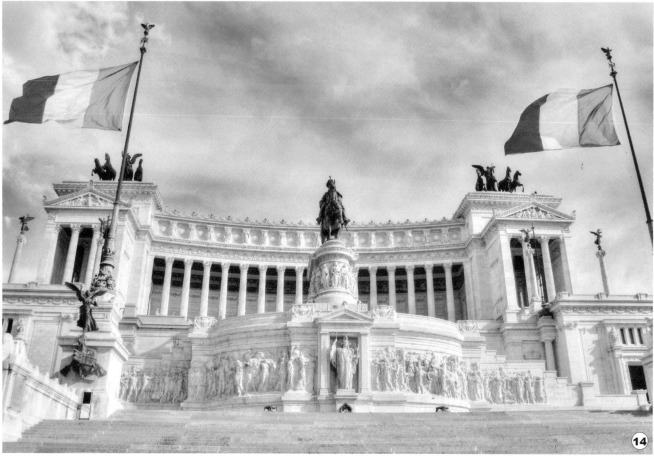

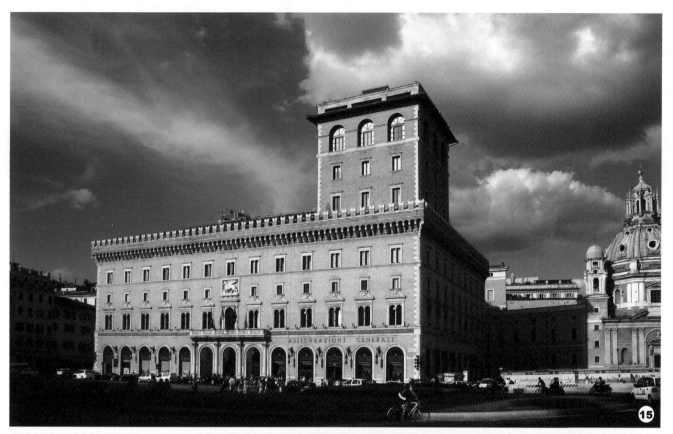

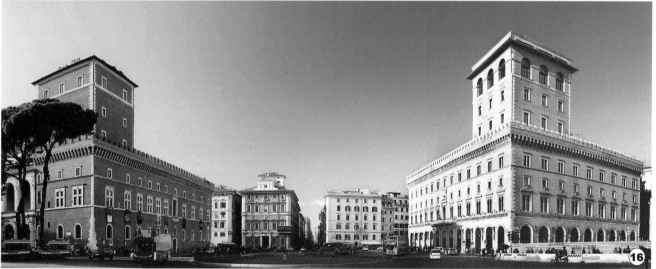

Across the street is the Venice Palace (Palazzo Venezia), a genuine Renaissance architectural gem (photo 16), which was actually the source of inspiration for the Generali Palace.

One of the most easily recognizable landmarks in Rome is the Castle of the Holy Angel (Castle Sant'Angelo) also known as the Mausoleum of Hadrian, finished in 139 A.D. (photo 17).

In front of the castle, the Sant'Angelo Bridge (photo 18) spans the Tiber River.

It is decorated with elegant sculptures of angels added by Pope Clement IX in 1668 (photos 19 and 20).

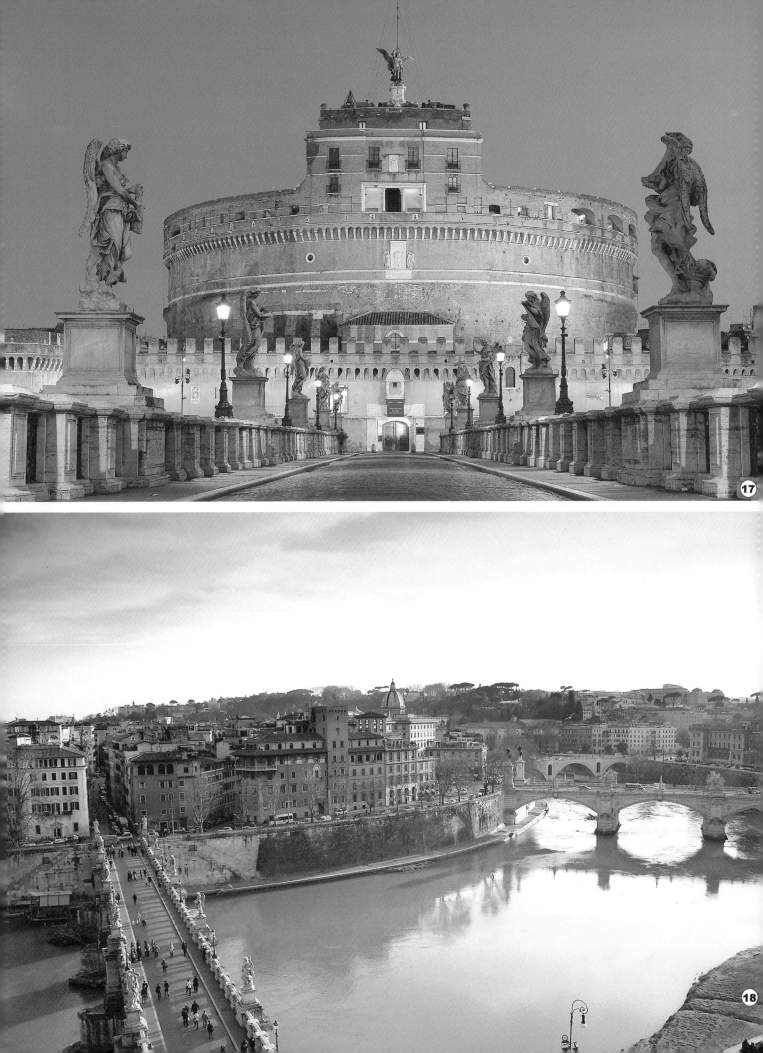

17

18

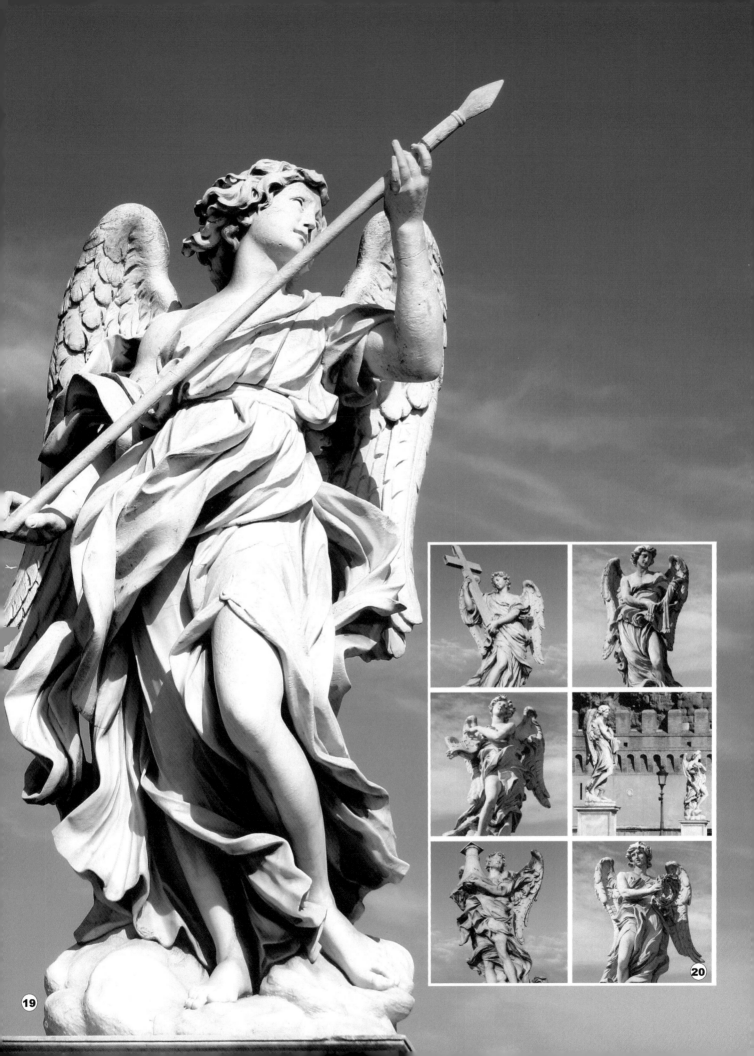

19

20

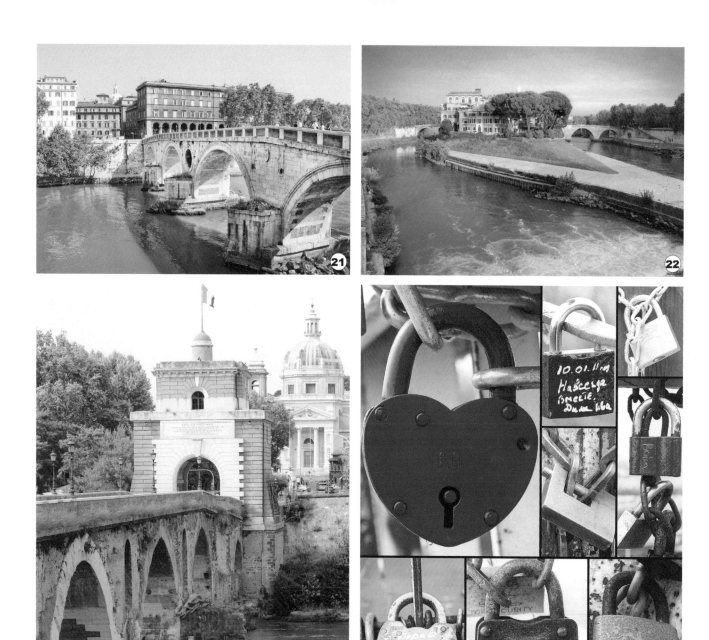

There are other beautiful bridges on the river Tiber, in Rome. Ponte Sisto (photo 21) is a beautiful historic bridge that connects Via del Pettinari to the Trastevere district.

Ponte Fabricio and Ponte Cestio connect the beautiful Tiber Island with the rest of Rome (photo 22).

Couples in love used to attach padlocks to the bridge called Ponte Milvio (photos 23 and 24), and then throw the keys in the Tiber to ensure this way that their love will remain unbroken. In 2012, the mayor banned this gesture in order to prevent damage to the historic bridge.

Rome is well known for its monumental columns. A marvelous example is the Column of Marcus Aurelius (Colonna di Marco Aurelio) from Piazza Colonna (photo 25).

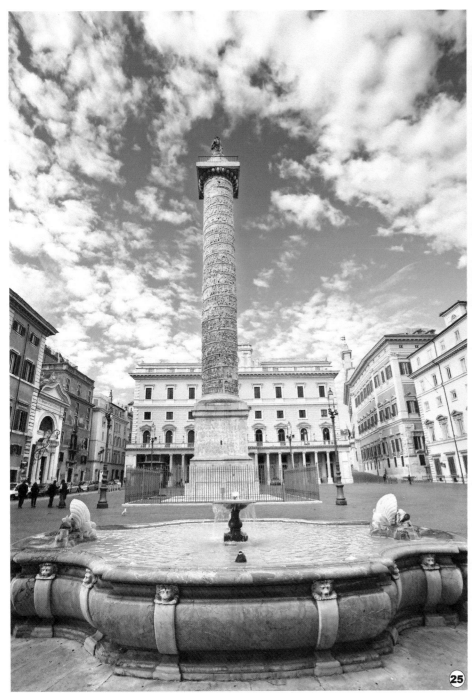

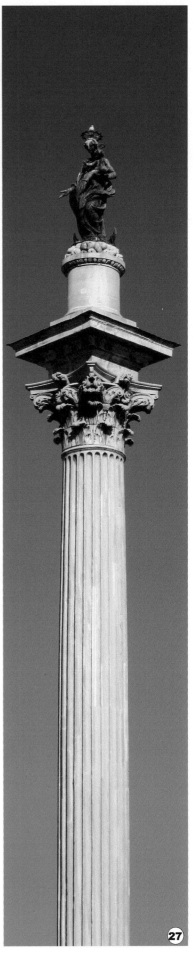

The Column of the Immaculate Conception (Colonna dell'Immacolata) was erected in the 19th century (photo 26).

The column from Piazza Santa Maria Maggiore dates back to 1614 (photo 27). They are both Marian columns, that is religious monuments honouring the Virgin Mary.

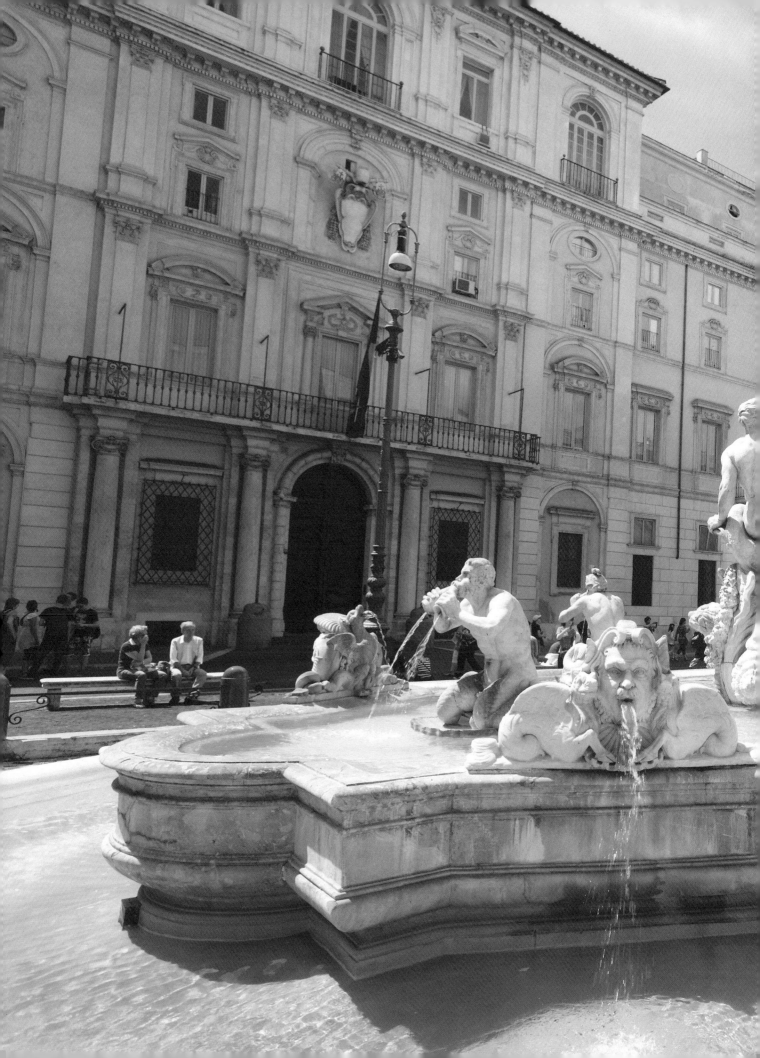

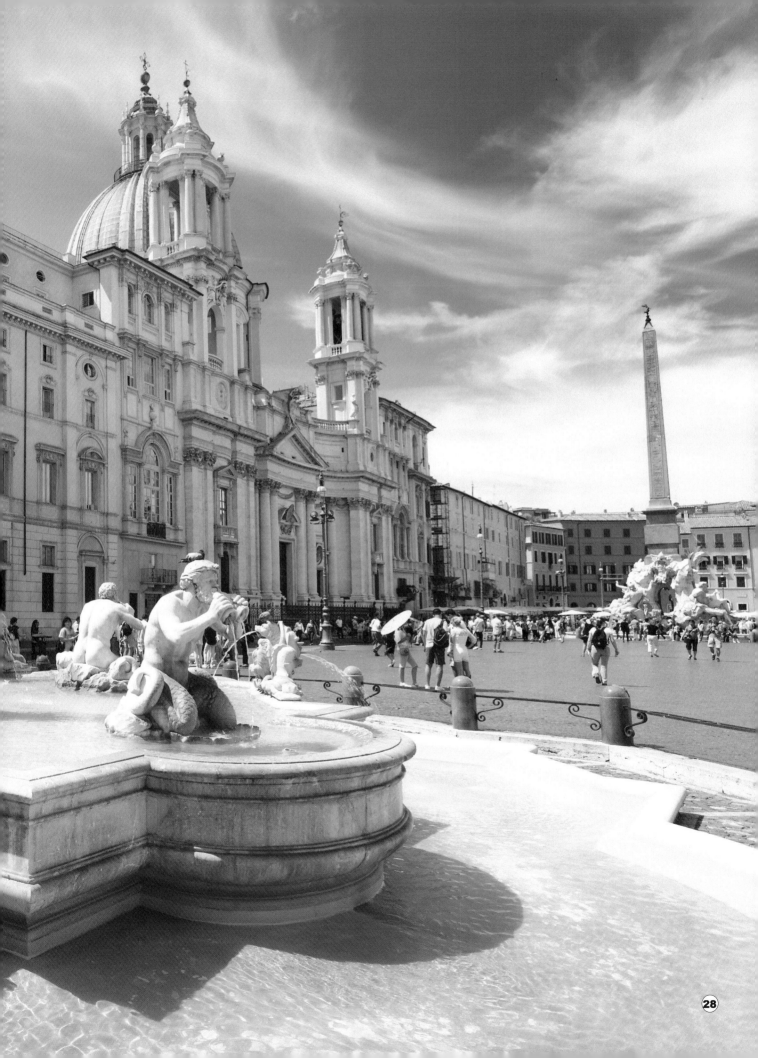

One specific feature of Rome is the big number of beautiful squares or "piazze" as the Italians call them. Some are very small, others are large, but they all have something special.

One of the most popular is Navona Square (Piazza Navona). It has an oval shape because it stands on the ruins of the Stadium of Domitian, where Romans once held chariot races (photo 28).

Many artists like painters, caricaturists, or photographers gather here to display and sell their works (photo 29).

Campo dei Fiori (photo 30) is another square in Rome that hosts a daily vegetable and fish market. Translated in English the name means "field of flowers" and it originates in the Middle Ages when the present square was a meadow. On February 17, 1600, the astronomer and philosopher Giordano Bruno was burned alive for heresy in this square.

Close to the Termini train station, one can find the semi-circular square of Piazza Republica (photo 31) with its beautiful Fountain of the Naiads, completed in 1888.

The Romans built the Pantheon (photo 32), one of the most mysterious buildings in Rome, between 118 and 125 A.D., and today after more than 1800 years, it is still standing almost intact. Initially, the Pantheon was a temple dedicated to the Roman gods, but in 609, it was converted into a church.

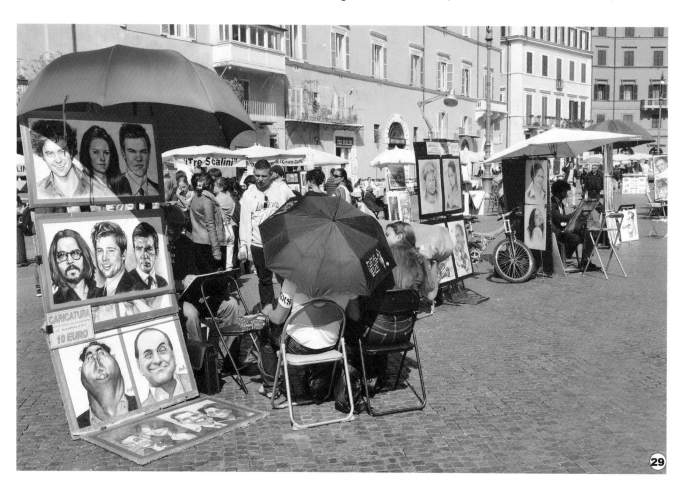

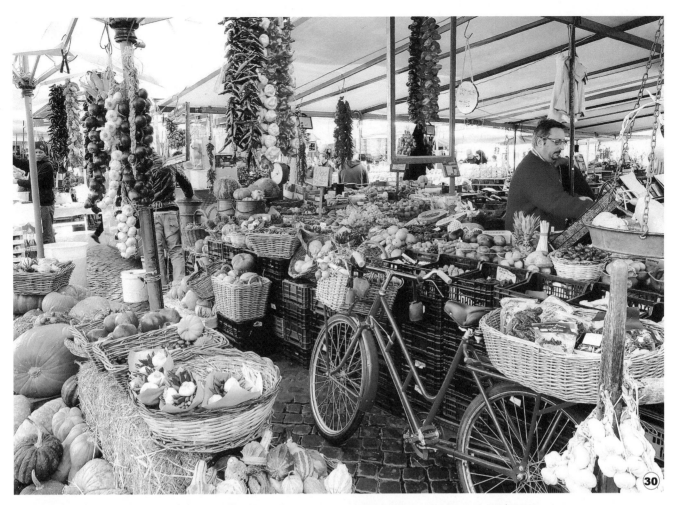

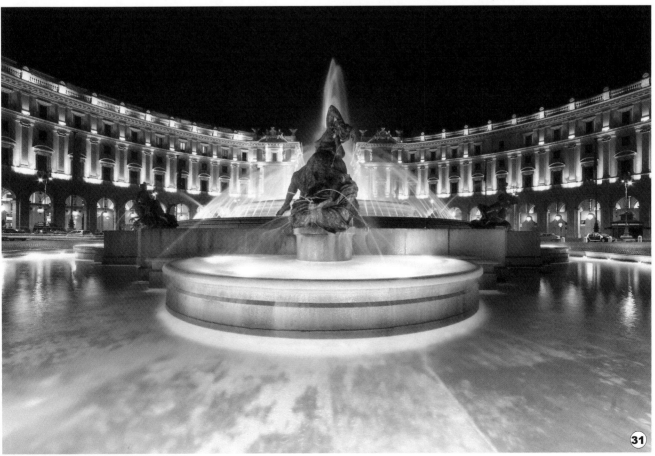

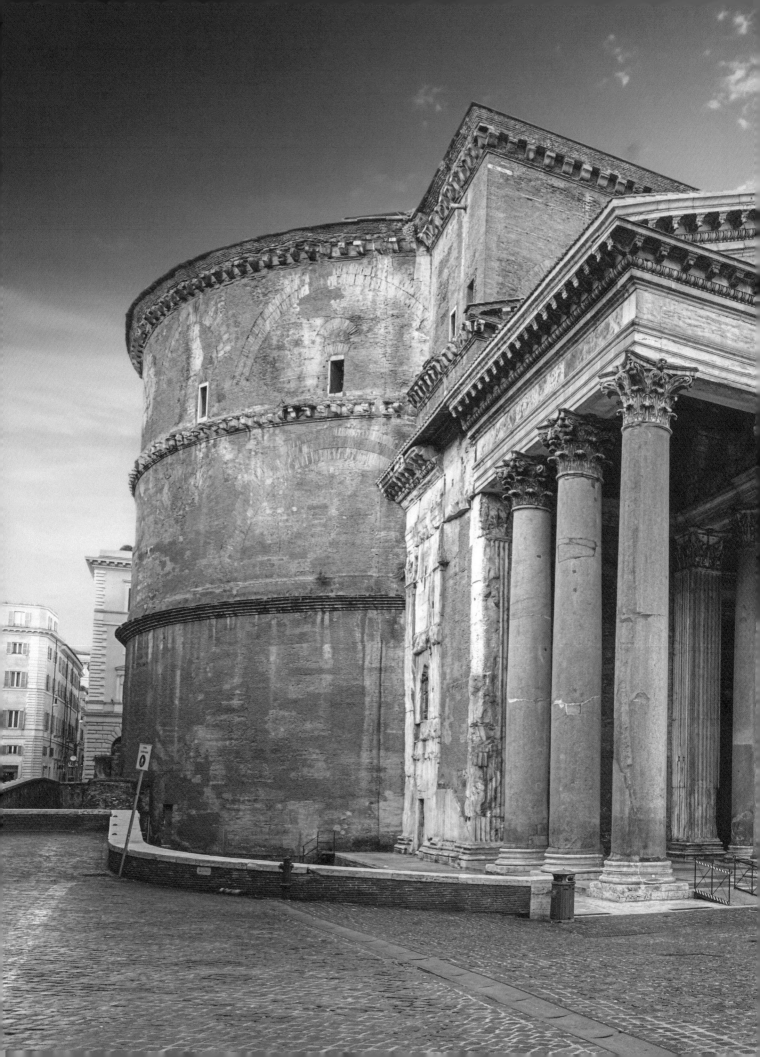

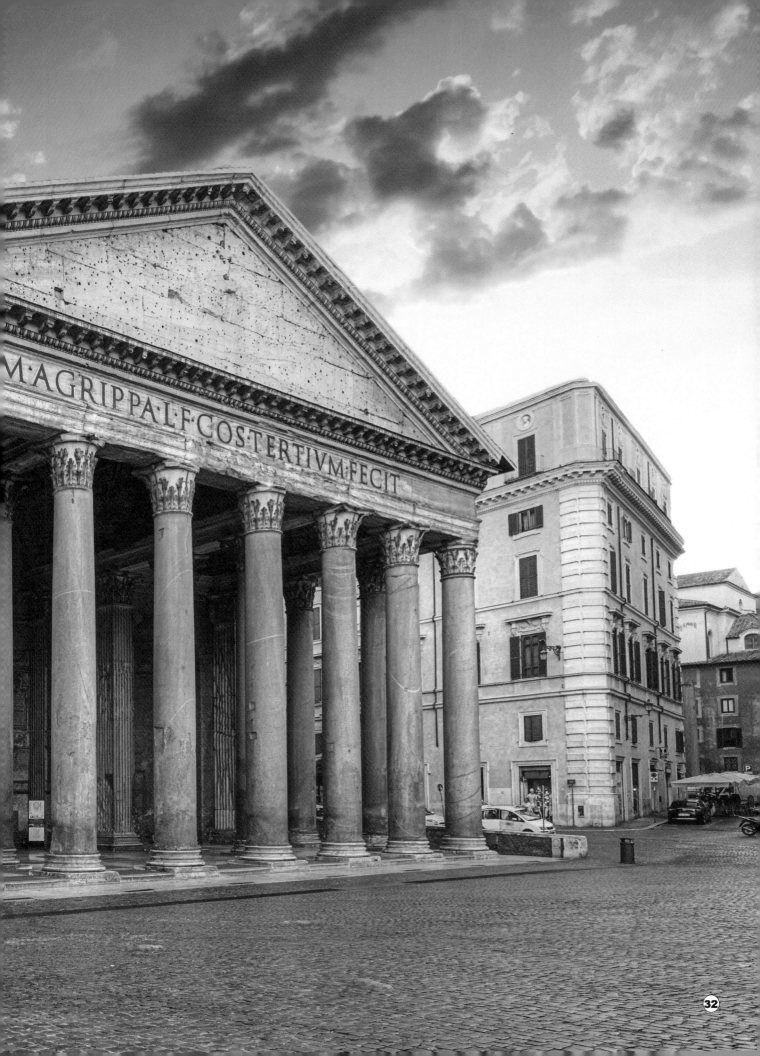

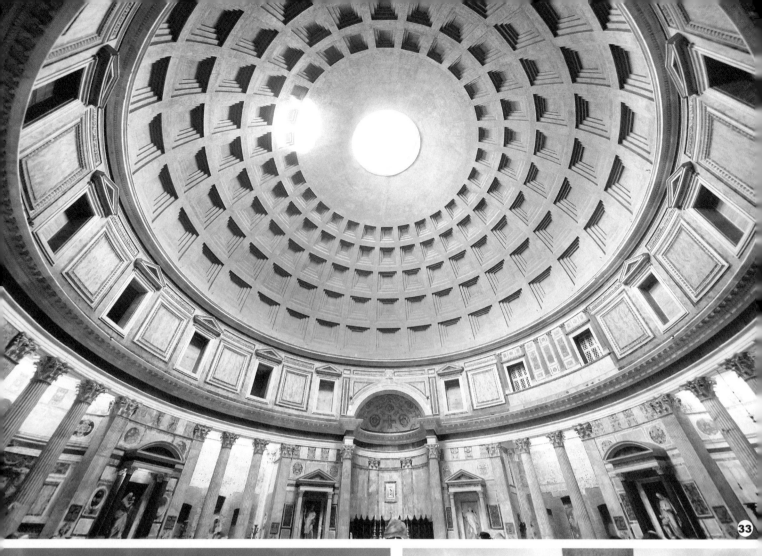

33

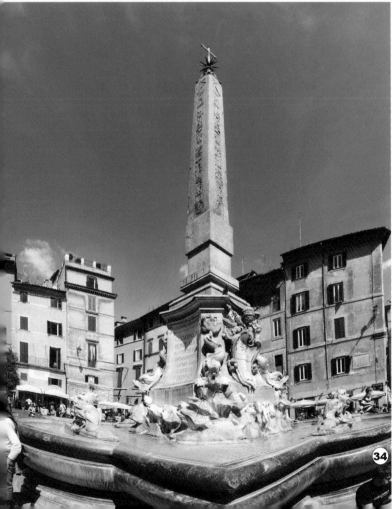

34

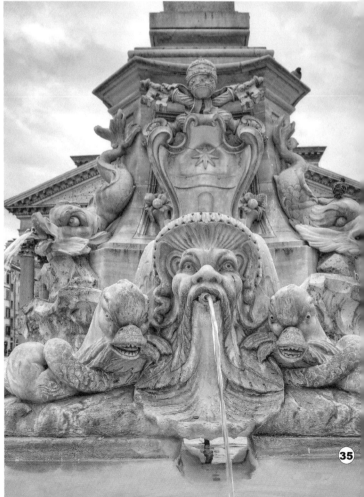

35

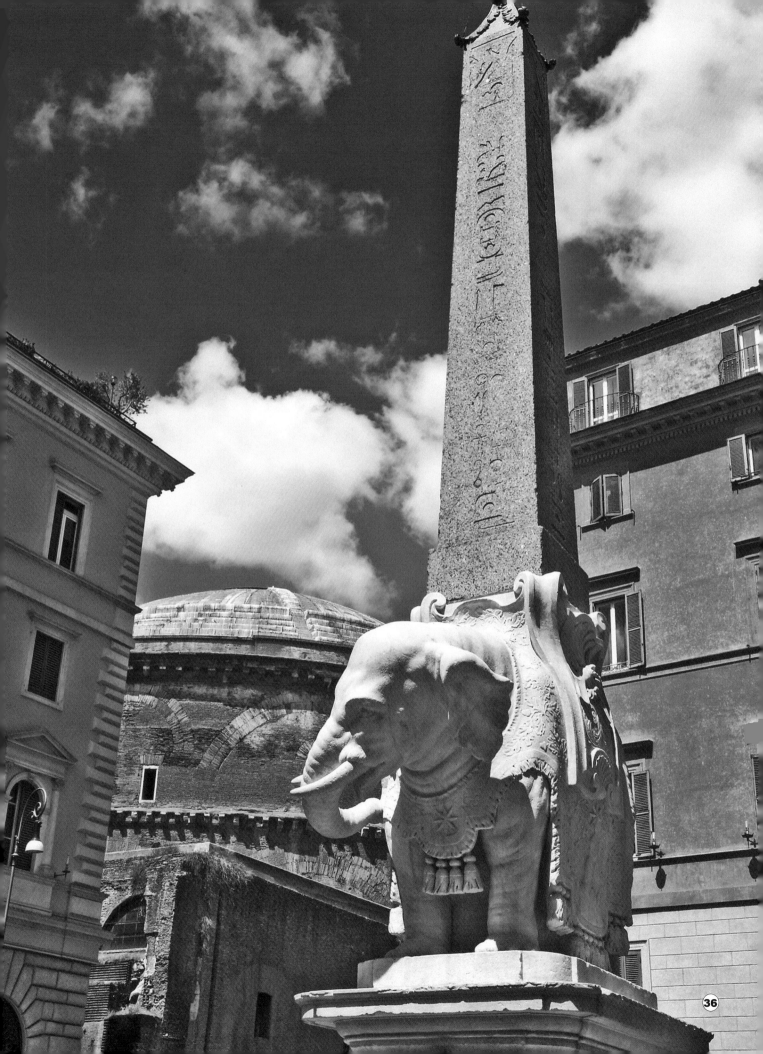

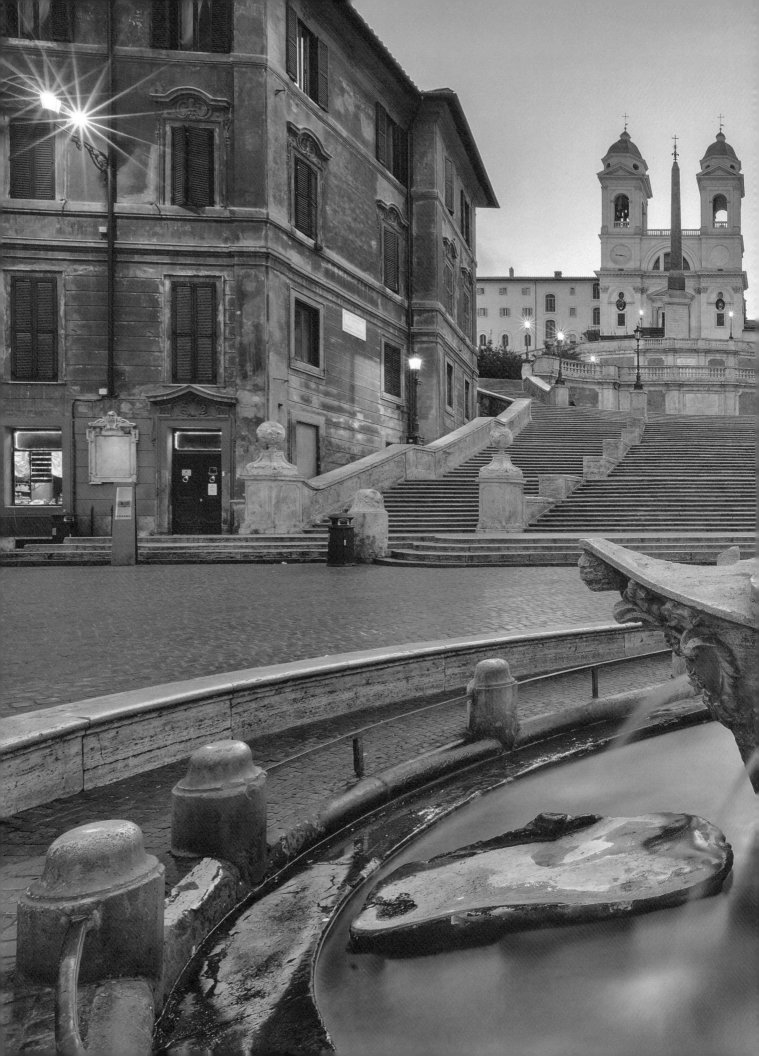

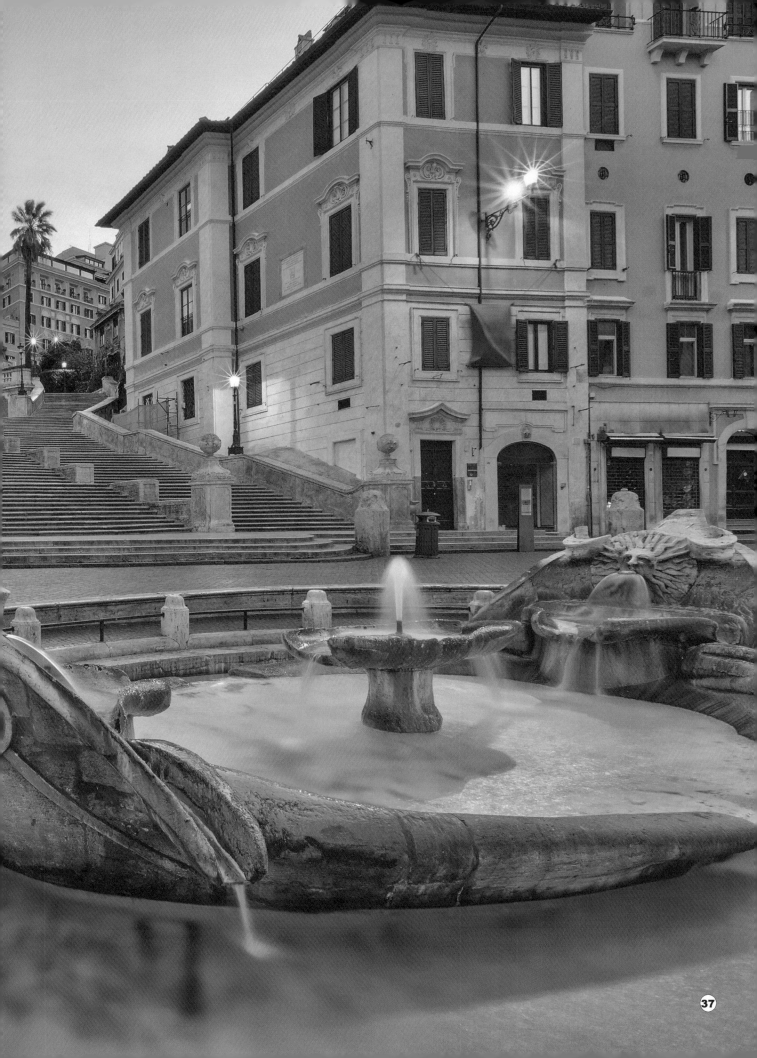

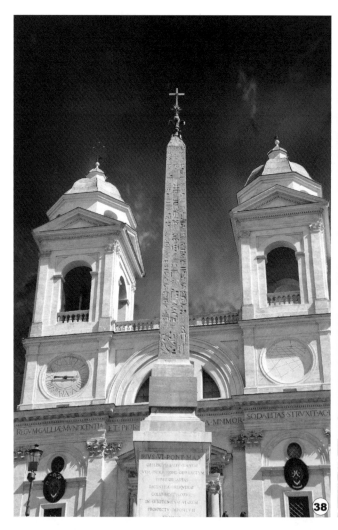

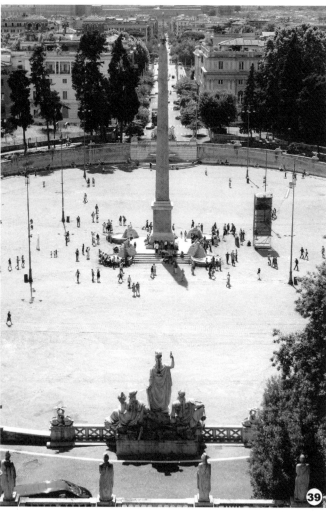

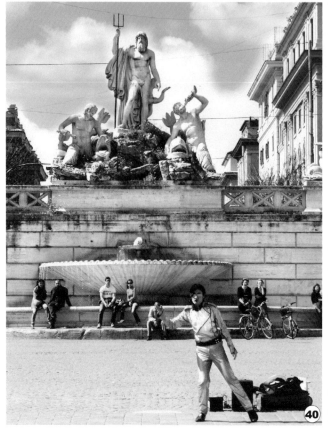

The magnificent dome of the Pantheon has an oculus (an opening), as the main source of natural light. The oculus has never been covered (photo 33).

In Piazza della Rotonda in front of the Pantheon, there is an impressive fountain: Fontana del Pantheon (photo 34).

In 1886, sculptor Luigi Amici made copies to replace the original marble figures (photo 35) from Fontana del Pantheon. Today, the originals are in the Museum of Rome.

Next to the Pantheon, there is the curious-looking Elefantino monument. It glorifies wisdom and depicts an elephant with an Egyptian obelisk on its back (photo 36).

One of the most popular places in Rome is the Spanish square (Piazza di Spagna) where the beautiful Fontana della Barcaccia is located (photo 37).

Another attraction located in Piazza di Spagna is Trinità dei Monti church, a genuine Renascentist masterpiece (photo 38).

Not far from Piazza di Spagna is the People's Square (Piazza del Popolo, photo 39). For centuries until 1826, this was the place where the government held public executions.

On one side of the People's square, there is the beautiful fountain of Neptune (photo 40).

Two similar churches (photo 41) dominate the entrance from Via del Corso: Santa Maria in Montesanto (left, built between 1662 and 1675) and Santa Maria dei Miracoli (right, built between 1675 and 1679).

Likely the most visited and busiest place in Rome is the Trevi Fountain (Fontana di Trevi, photo 42). This is no surprise considering the beauty of this Baroque architectural work of art. The Romans built the fountain between 1732 and 1762. It is the largest baroque fountain in Rome, and probably the most famous fountain in the world.

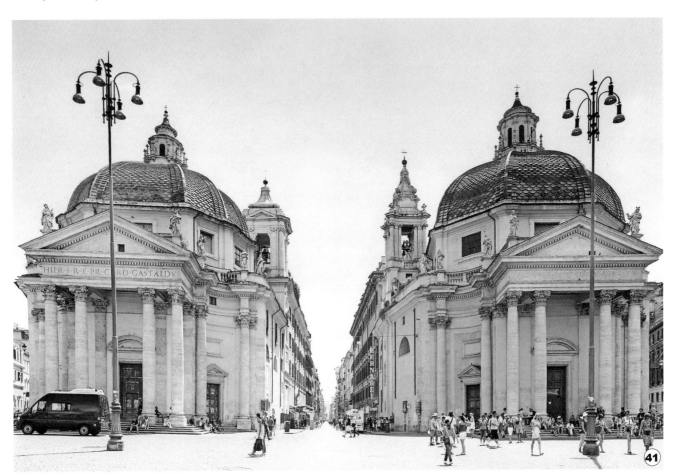

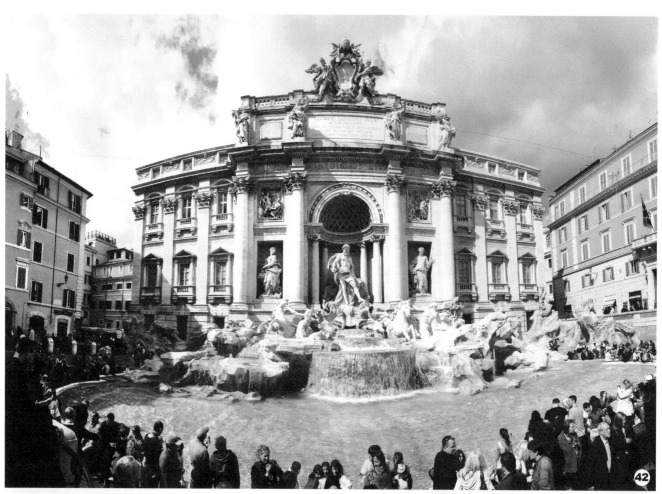

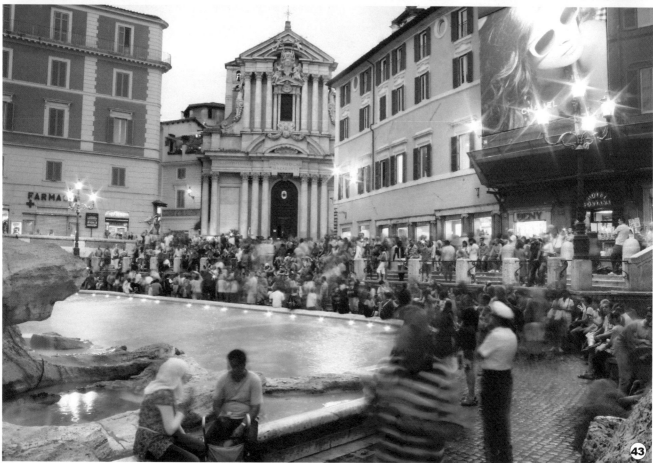

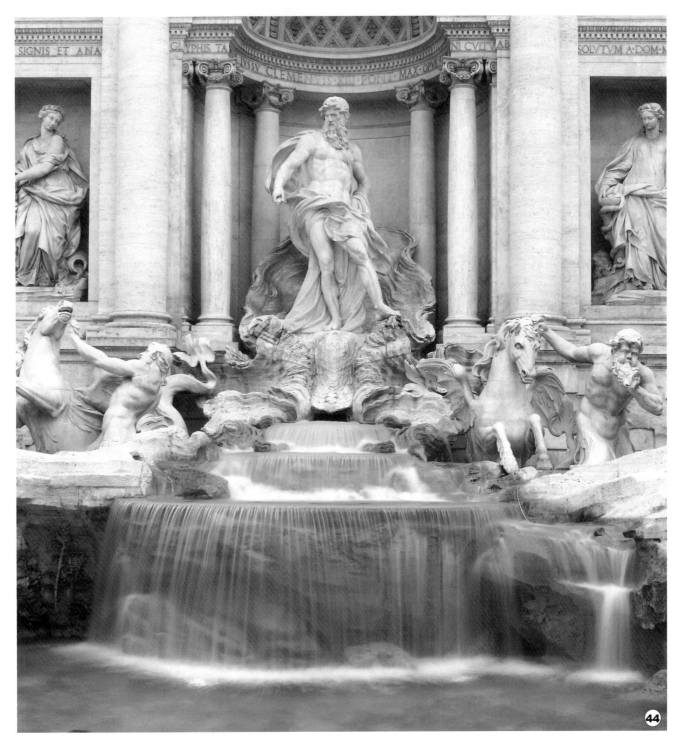

Crowded day and night (photo 43), Fontana di Trevi is a romantic place, and it is often the chosen scene for marriage proposals.

Symbols and sculptures beautifully decorate the fountain. In the middle lies the statue of Ocean or Oceanus (photo 44), the god of the river that circled the world from the ancient Roman mythology.

It is believed that people that throw a coin in the fountain will come back to visit Rome. This is a very popular custom and it is estimated that tourists throw about 3000 euro in the Trevi fountain each day.

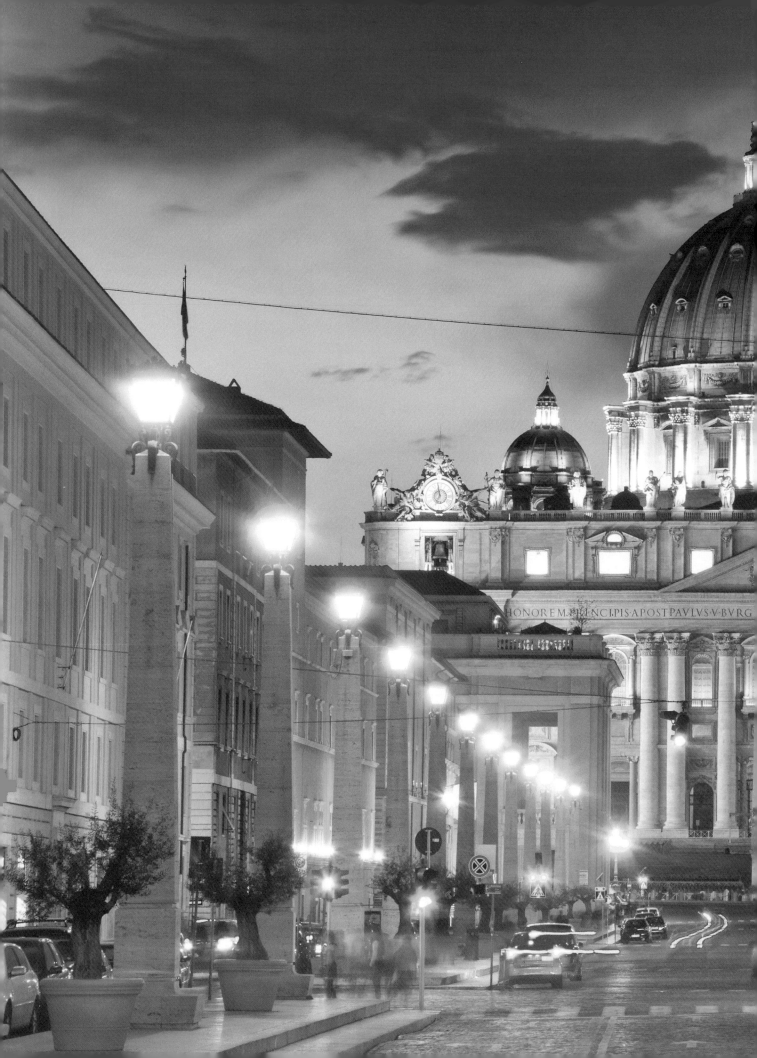

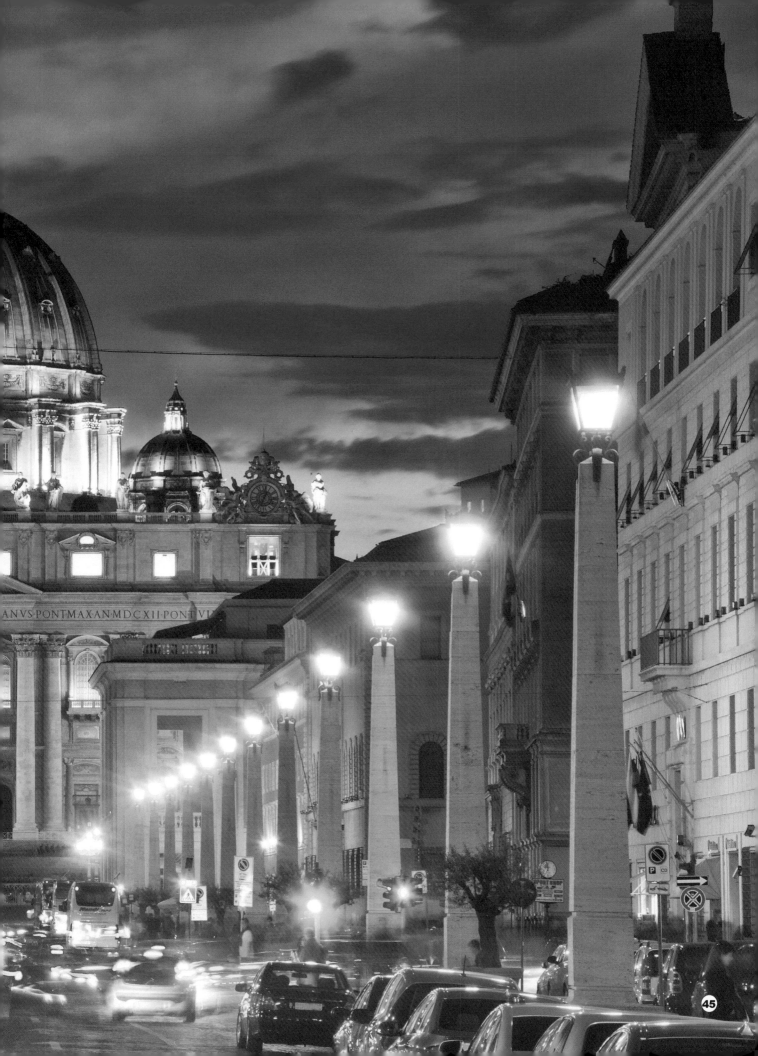

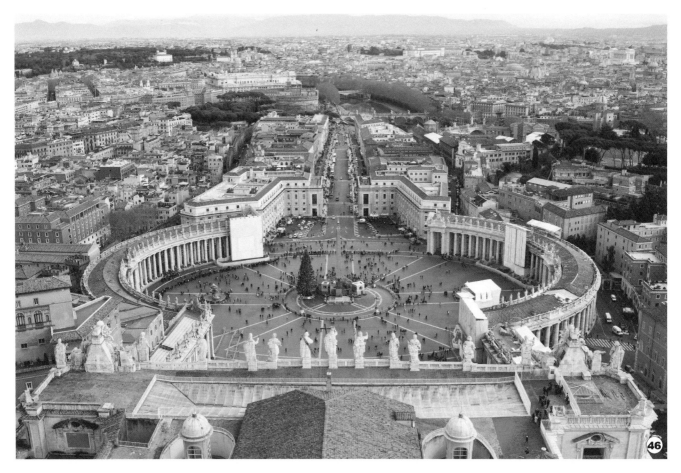

Saint Peter's Basilica (Basilica di San Pietro in Vaticano) is an impressive Late Renaissance church constructed between 1506 and 1626 (photo 45).

In front of the church, there is a massive square, Saint Peter's Square (Piazza di San Pietro), where crowds of up to 80,000 people gather when the Pope presides at religious services (photo 46).

On top of the Basilica di San Pietro, there are sculptures of religious figures: Jesus Christ and the Apostles (photo 47).

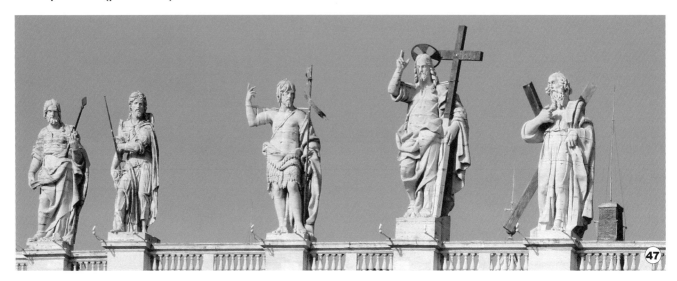

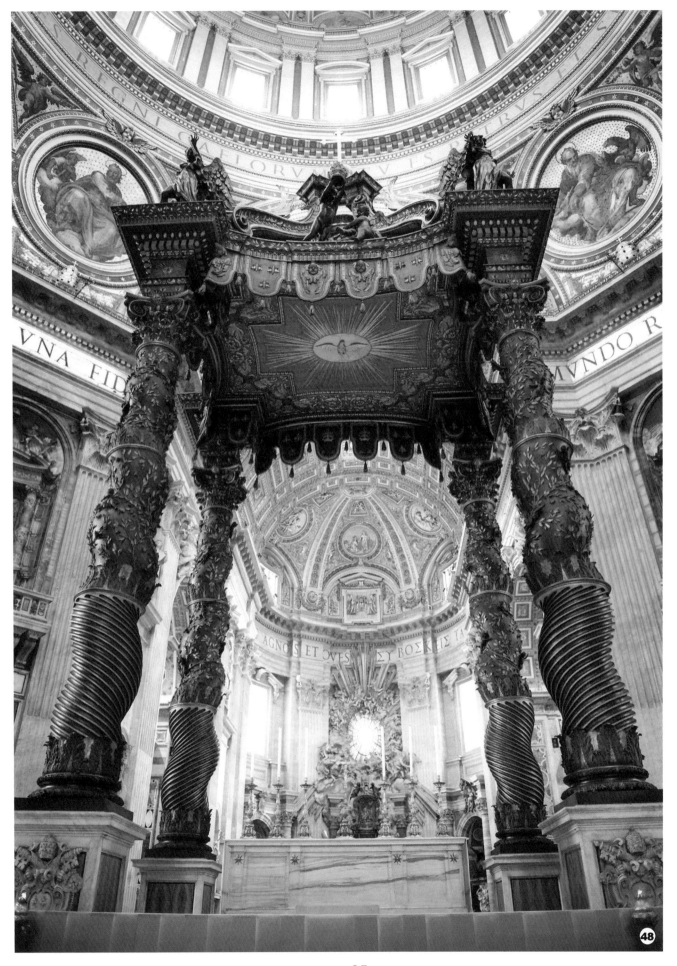

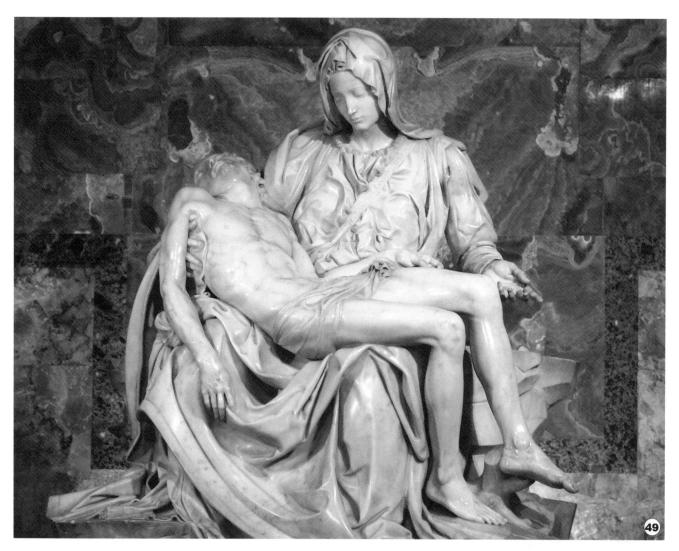

Inside the church, there is a treasure of artworks designed by famous artists. St. Peter's Baldachin (photo 48) is a large bronze sculpture created by Gian Lorenzo Bernini to mark the tomb of Saint Peter, which many believe lies underneath the church.

Another famous work is La Pieta (photo 49), a Renaissance masterpiece sculpted by Michelangelo Buonarroti between 1498 and 1499.

The Vatican Gardens (photo 50), where popes have relaxed and meditated since 1279, are now open for the public, and they make a nice walk inside the secret city of Vatican.

Among the buildings and monuments inside the Vatican gardens, a visitor can find the interesting medieval Tower of Saint John (photo 51).

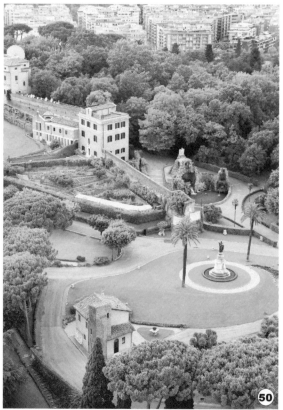

36

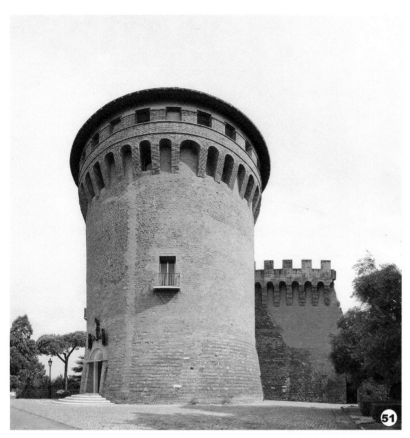

The Vatican Museum (photo 52) contains a remarkable collection of art works. It was initiated by Pope Julius II (1503-1513) as a collection of sculptures. The museum is actually a complex gallery containing several small museums, each section hosting different collections.

The Gallery of Maps is one of the well-known sections of the Vatican Museums. The gallery has a richly decorated golden ceiling (photo 53), and includes paintings by Mannerist (late Renaissance) Italian artists.

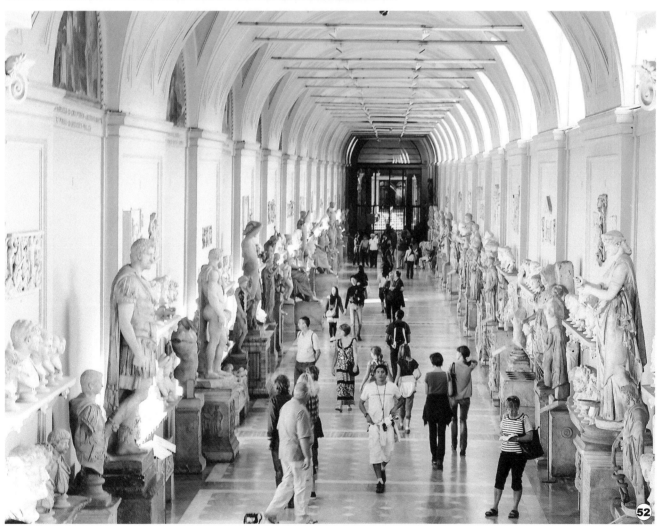

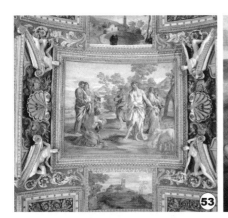

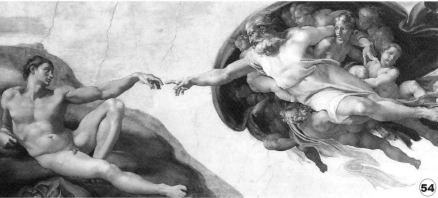

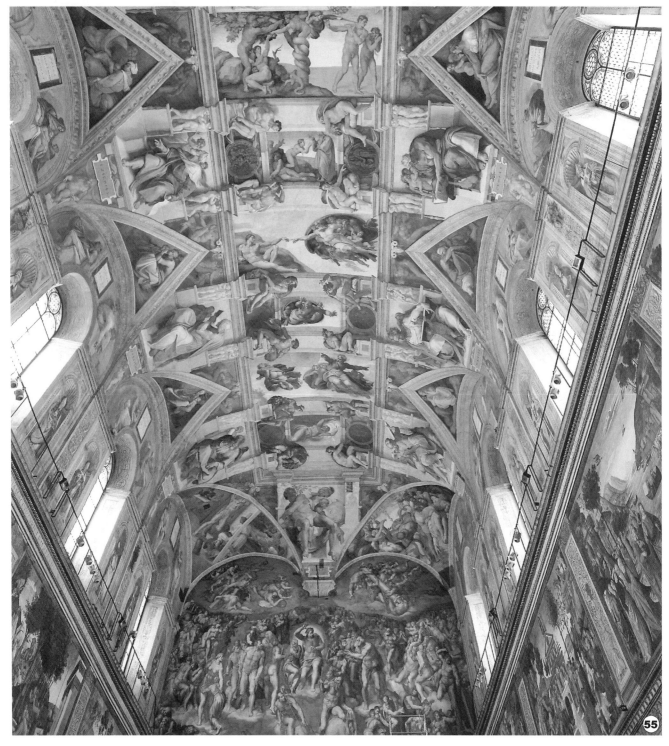

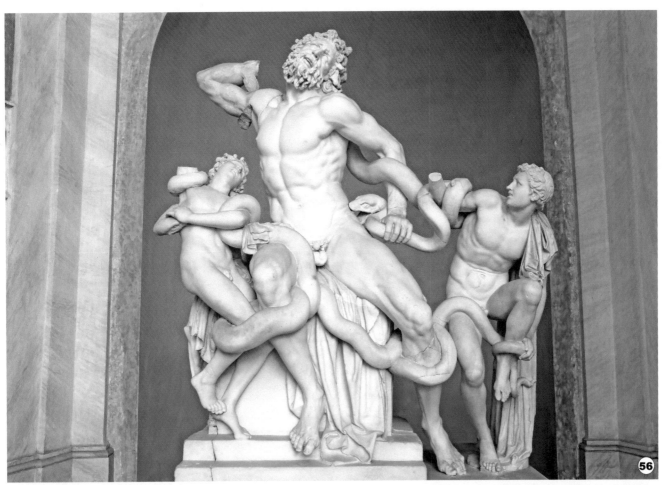

56

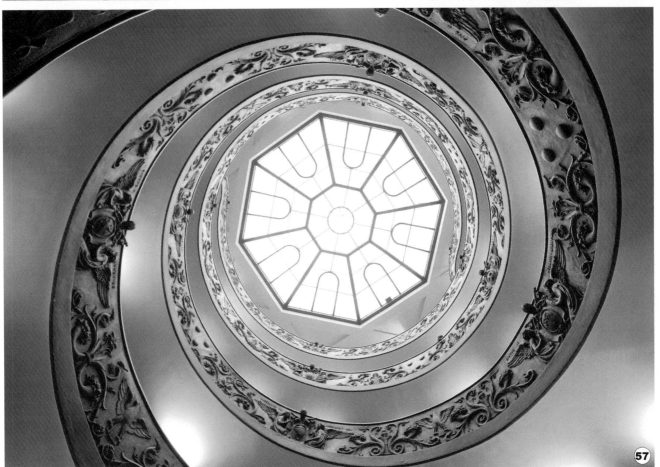

57

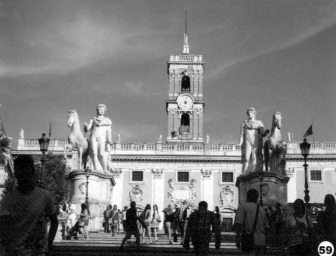

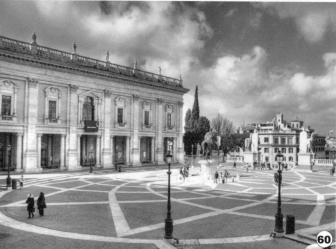

The crown jewel of the Vatican Museums is the Sistine Chapel (photo 55).

Maybe the most well known fresco from the Sistine Chapel is "The creation of Adam" that illustrates the biblical creation of Adam, the first man, by God (photo 54).

Another masterpiece from the Vatican Museums is the ancient sculptural group representing Laocoön and his sons (photo 56). It is believed that the sculpture, depicting the Trojan priest Laocoön and his sons Antiphantes and Thymbraeus fighting sea serpents, dates from sometime between 27 and 68 B.C.

At the end of the tour, visitors leaving the Vatican Museums reach the amazing spiral staircase made of two intertwined spirals, one going up and one going down (allowing people to descend without meeting people ascending). Natural light illuminates it through a canopy located above the stairs (photo 57).

Rome is built on seven hills. One of them is the Capitoline Hill (Campidoglio) and on its highest summit the massive church of Santa Maria in Aracoeli al Campidoglio (photo 58) is located.

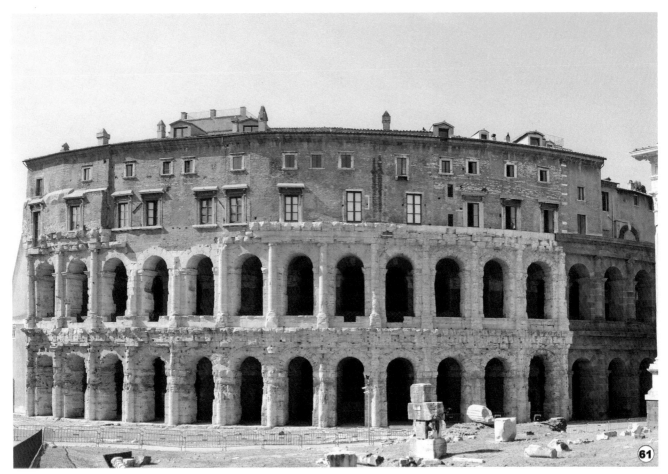

Another landmark from the Capitoline Hill is the Senate Palace (Palazzo Senatorio). It was built between the 13th and 14th centuries and has a double ramp of stairs designed by Michelangelo (photo 59).

Two beautiful statues representing the Dioscuri and their horses flank the upper end of this ramp (photo 62).

The square in front of the Senate Palace is the Campidoglio square (Piazza del Campidoglio), also designed by Michelangelo around 1560 (photo 60).

Not far away from the Capitoline Hill, lies the ancient open-air theater called Theater of Marcellus (Teatro di Marcelo, photo 61). Completed in 13 B.C., it was the most important theater in ancient Rome.

The best place to be in Rome on a hot summer day is the Villa Borghese park (photo 63). This is a very large landscape garden containing the Galleria Borghese museum, a lake and several other attractions.

During a walk around Villa Borghese, one can see the Temple of Aesculapius (photo 64) or the water spouting lion statues from Portico dei Leoni (photo 66).

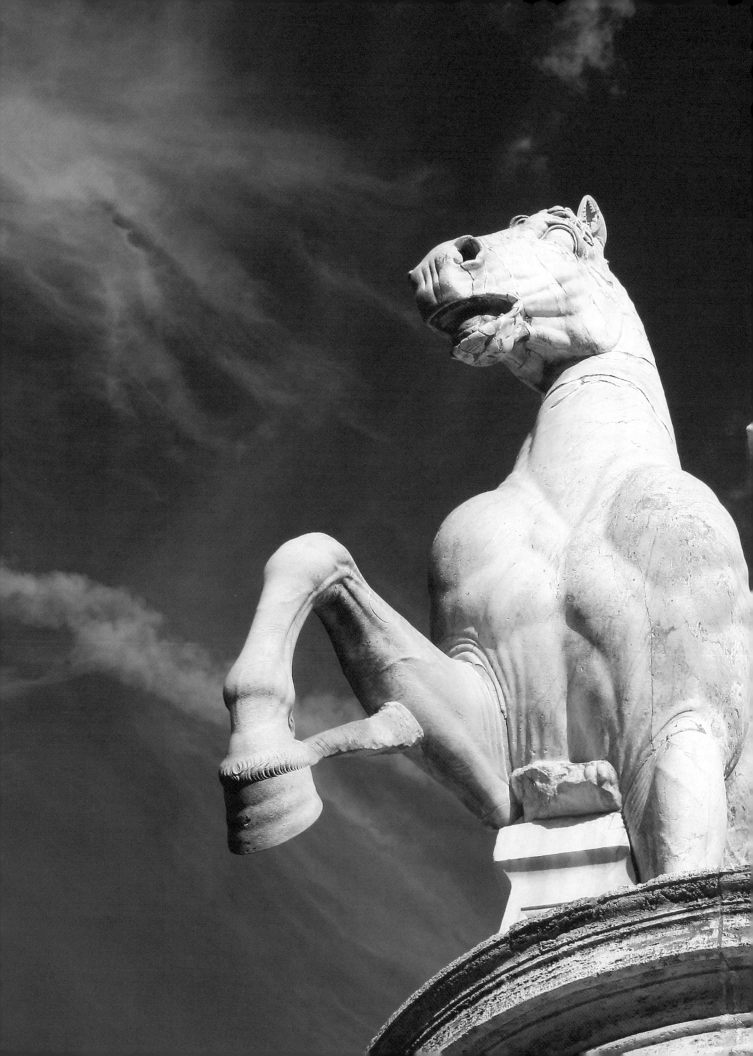

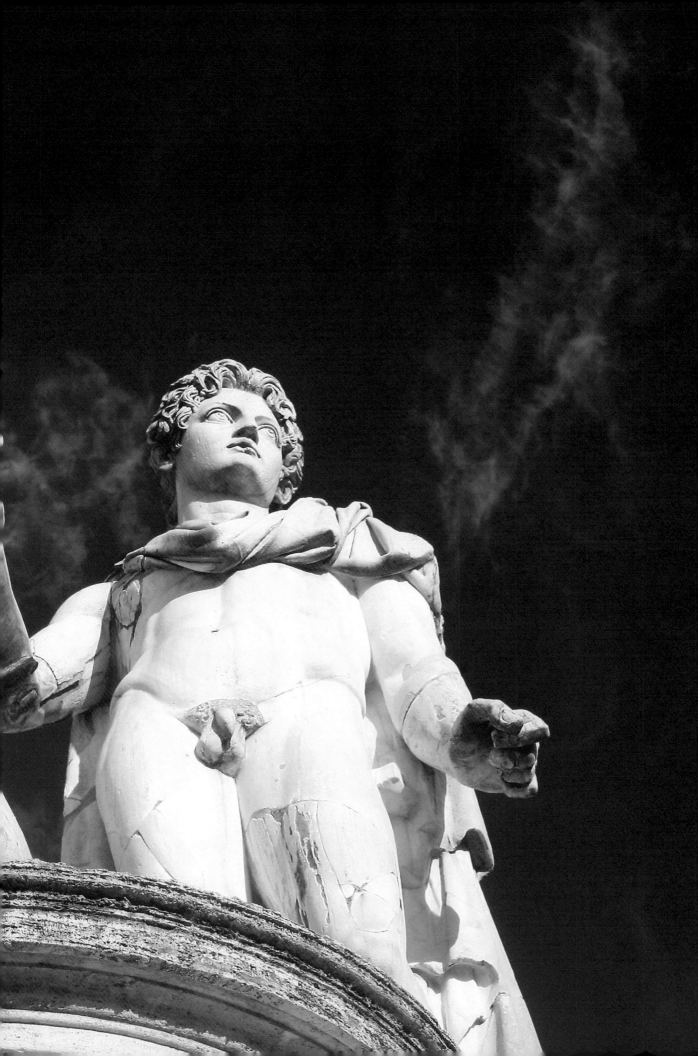

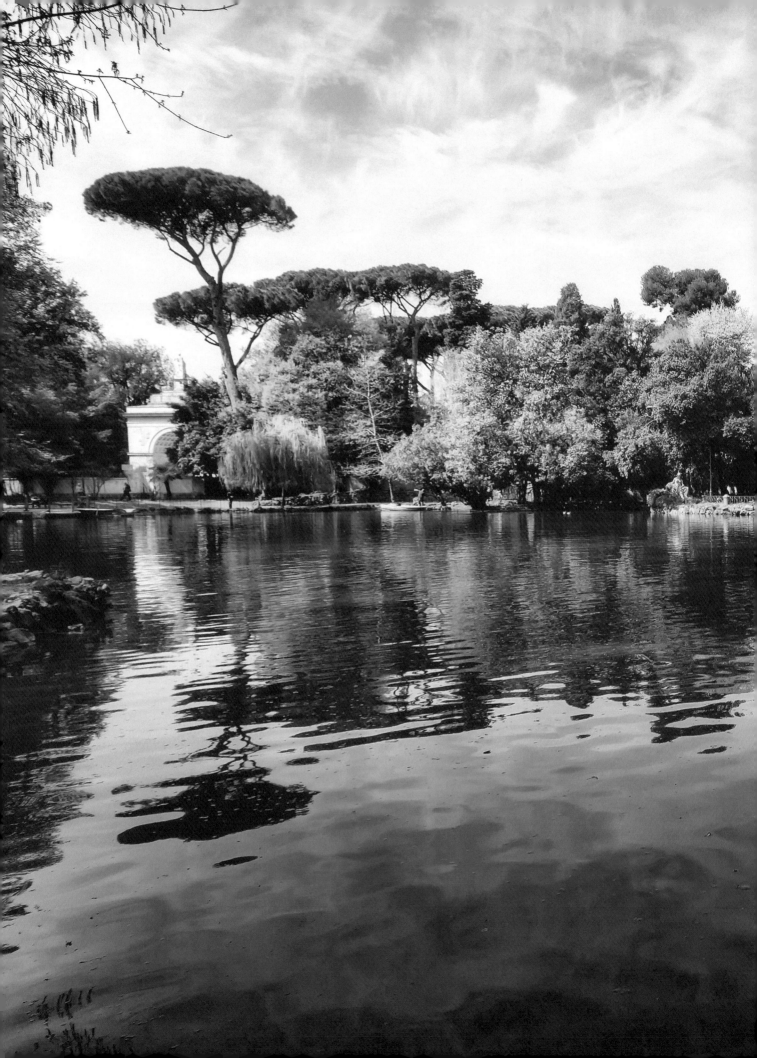

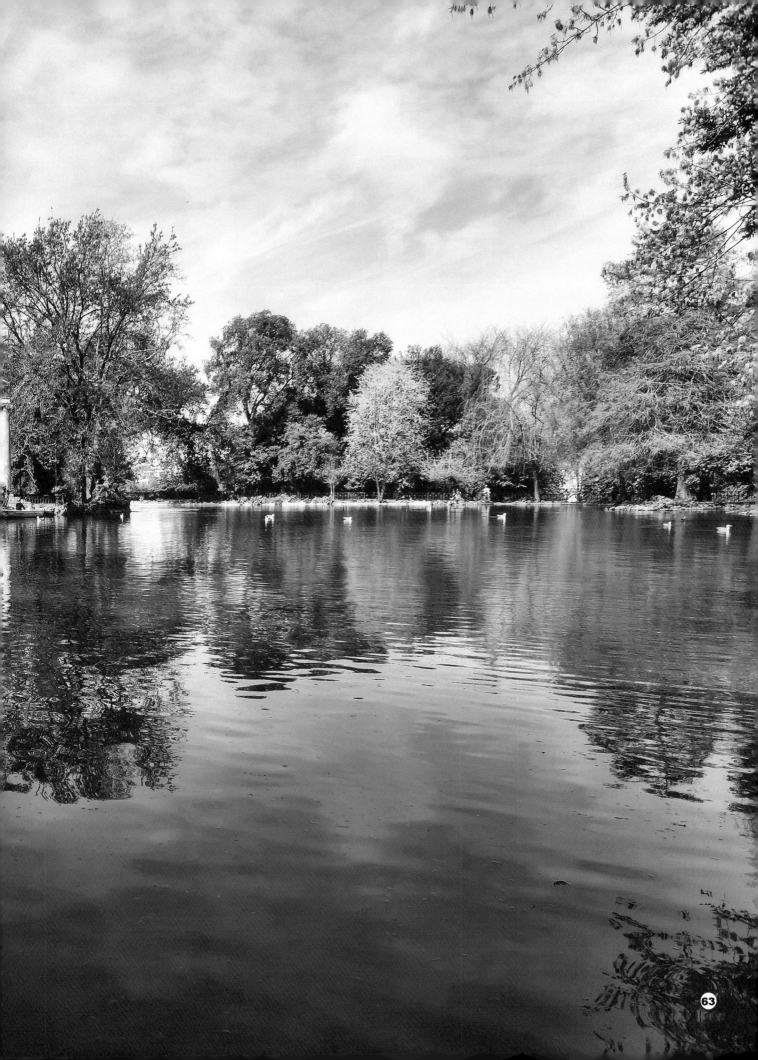

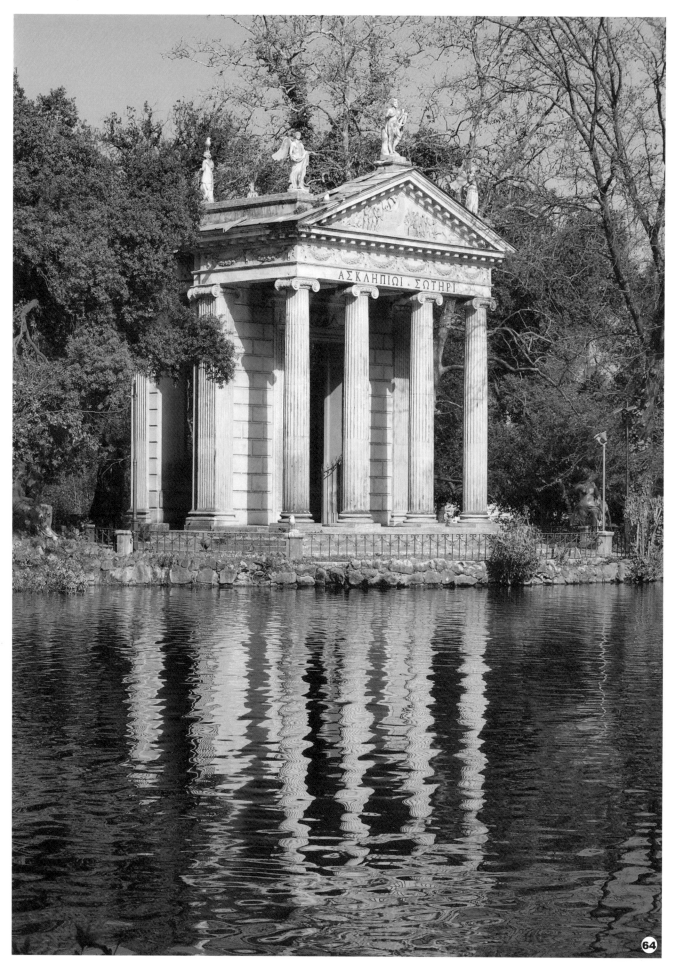

ΑΣΚΛΗΠΙΩΙ · ΣΩΤΗΡΙ

64

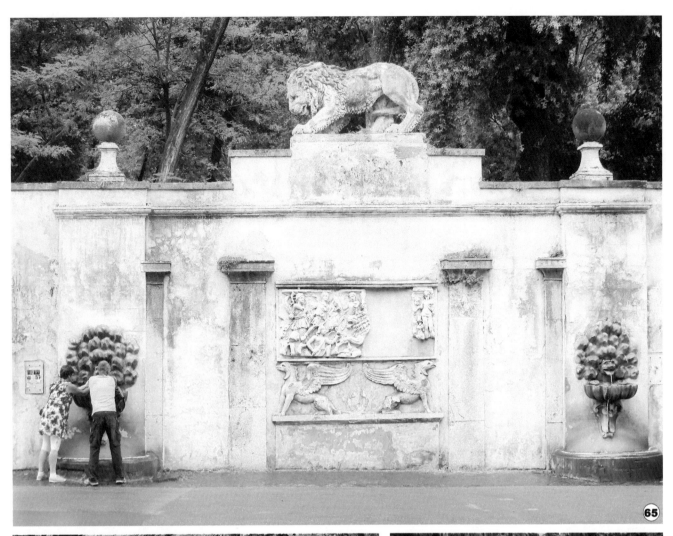

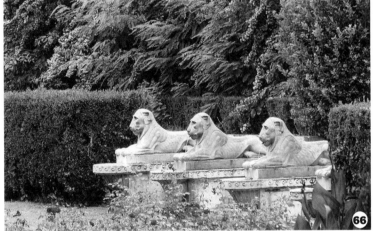

This elegant park is, in fact, rich in beautiful, refreshing fountains (photo 65).

The Villa Borghese gardens were the property of the Borghese family, and they were vineyards until 1605 when the area became a beautifully decorated park with sculptures (photo 67) and places for relaxation, including a zoo.

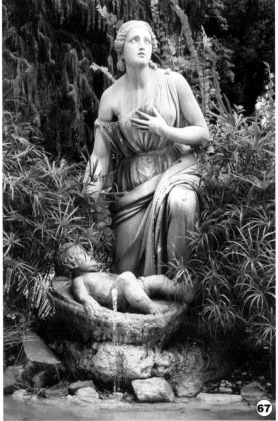

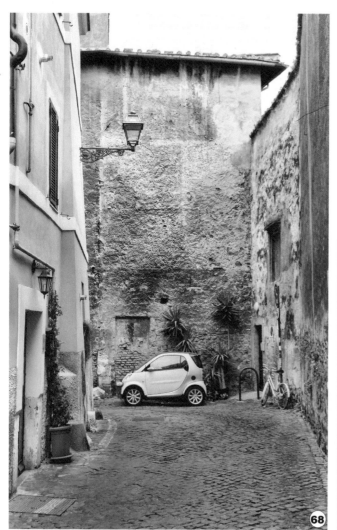

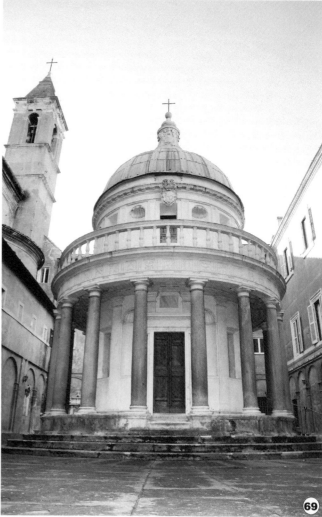

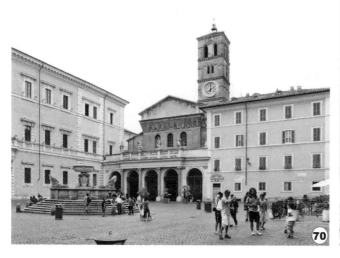

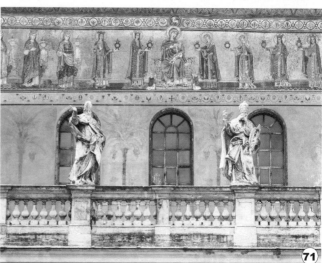

A visit to Rome must include a stroll in the medieval area of Trastevere (photo 68). It is the only part of Rome that survived the medieval times. Here one can find landmarks such as Ponte Sisto, the Gianicolo hill, Tiber Island or the church of Santa Maria in Trastevere (Basilica di Santa Maria in Trastevere, photo 70).

It is considered one of the oldest churches in Rome, the first sanctuary dating from 221 A.D.

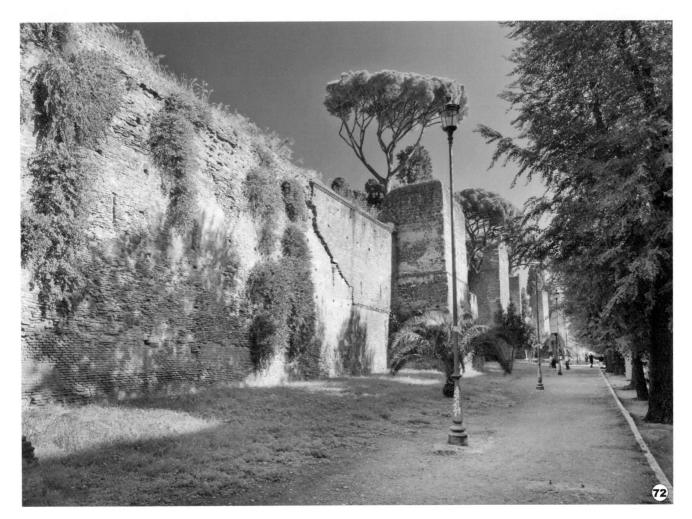

The exterior of the church is decorated with an amazing 12th century golden mosaic (photo 71), and the inside contains other beautiful mosaics dating from the 13th century.

One important religious edifice in Trastevere is the Church of Saint Peter (Chiesa di San Petro) in Montorio with its famous circular temple (Il Tempietto, photo 69).

During the Roman period, defense walls were erected to protect the city, and visitors can still see part of them today. Emperors Aurelian and Probus built these Aurelian Walls (Mura aureliane, photo 72) between 271 and 275 A.D.

The old defense walls contain several monuments and gates. Among the remarkable ones are the Pyramid of Caius Cestius and Porta San Paolo (photo 73).

Michelangelo designed the Porta Pia gate and finished it in 1565 (photo 74).

Ostia Antica (photo 75) was the harbor city of the ancient Rome. This site is about 20 minutes from Rome and it is famous for its well-preserved sculptures, ancient architecture, mosaics and bas-reliefs (photos 76-79).

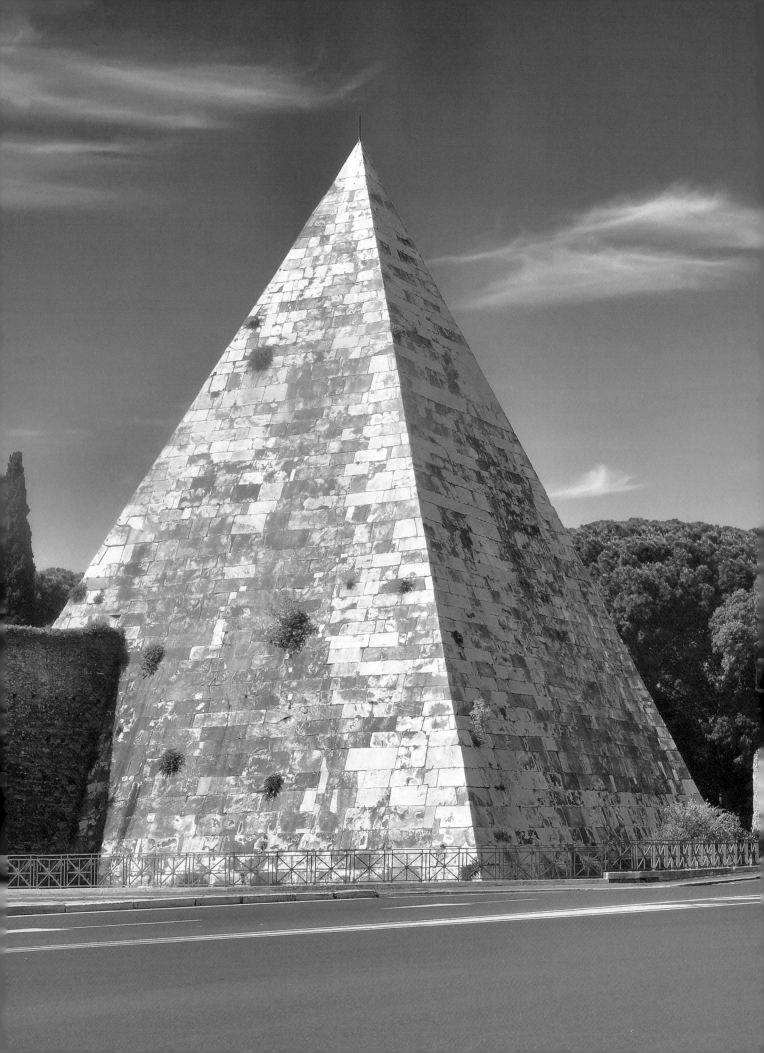

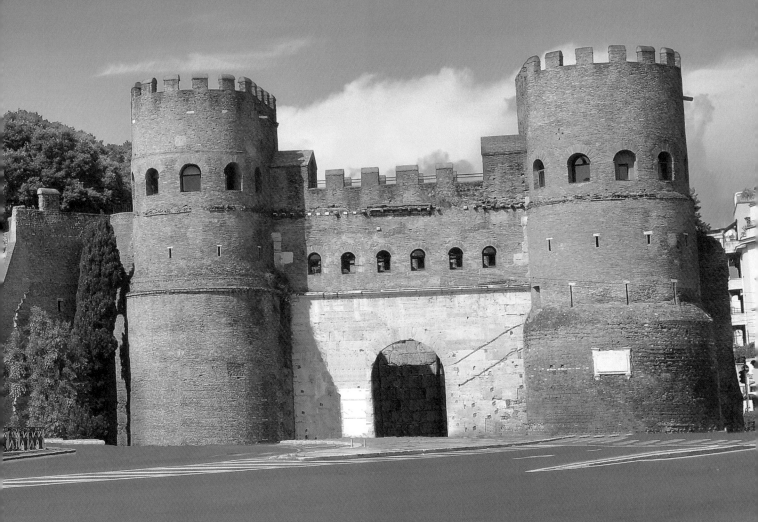

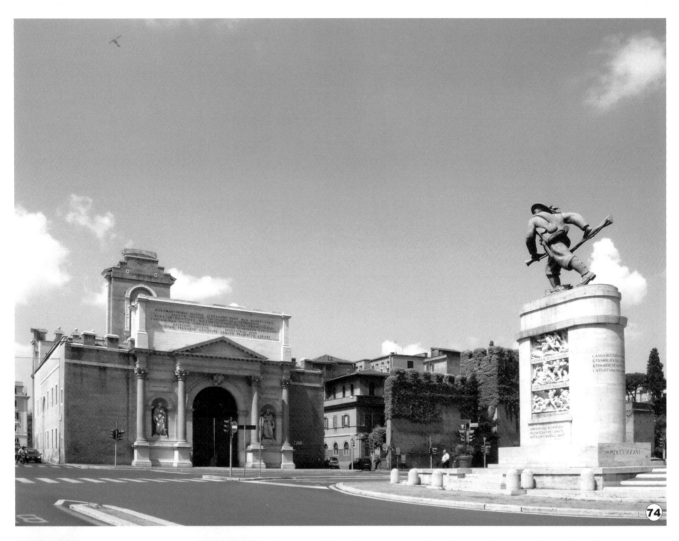

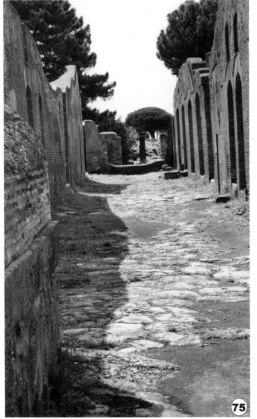

An excellently preserved antique theater, from the first century B.C. is still standing here. The theater continues to host public events, especially during summer (photo 80).

In Ostia Antica there is also a medieval castle, the castle of Julius II (photo 81), finished in 1484. For centuries, it was a papal residence.

Antique Rome had many public baths called "terme". These were facilities for bathing, but at the same time a place where people would gather to socialize. Very famous were the Baths of Caracalla (Terme di Caracalla) and the preserved remains of this complex still exist today (photo 82).

The Baths of Diocletian (Thermae Diocletiani, photo 83) were the largest imperial public baths. Today, some parts of them are incorporated in other buildings, like the church of Santa Maria degli Angeli e dei Martiri or the National Roman Museum.

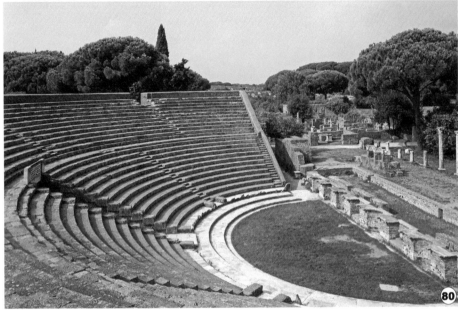

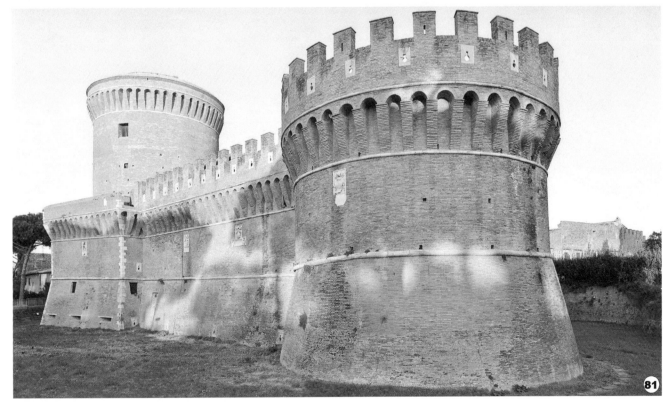

53

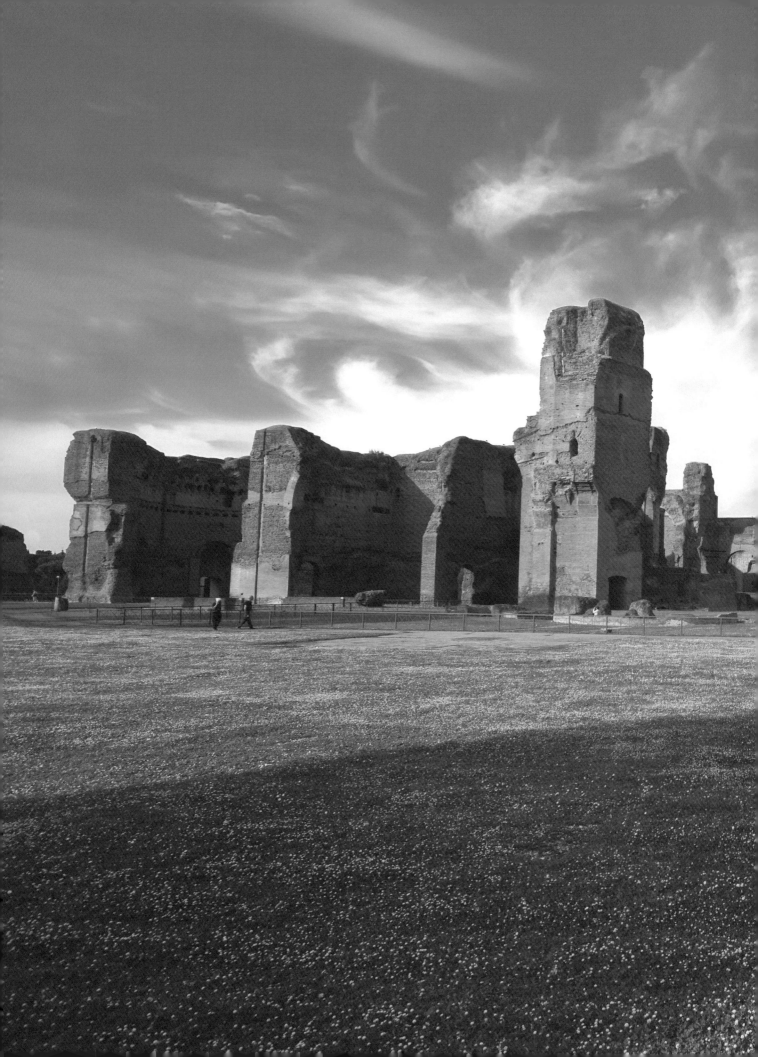

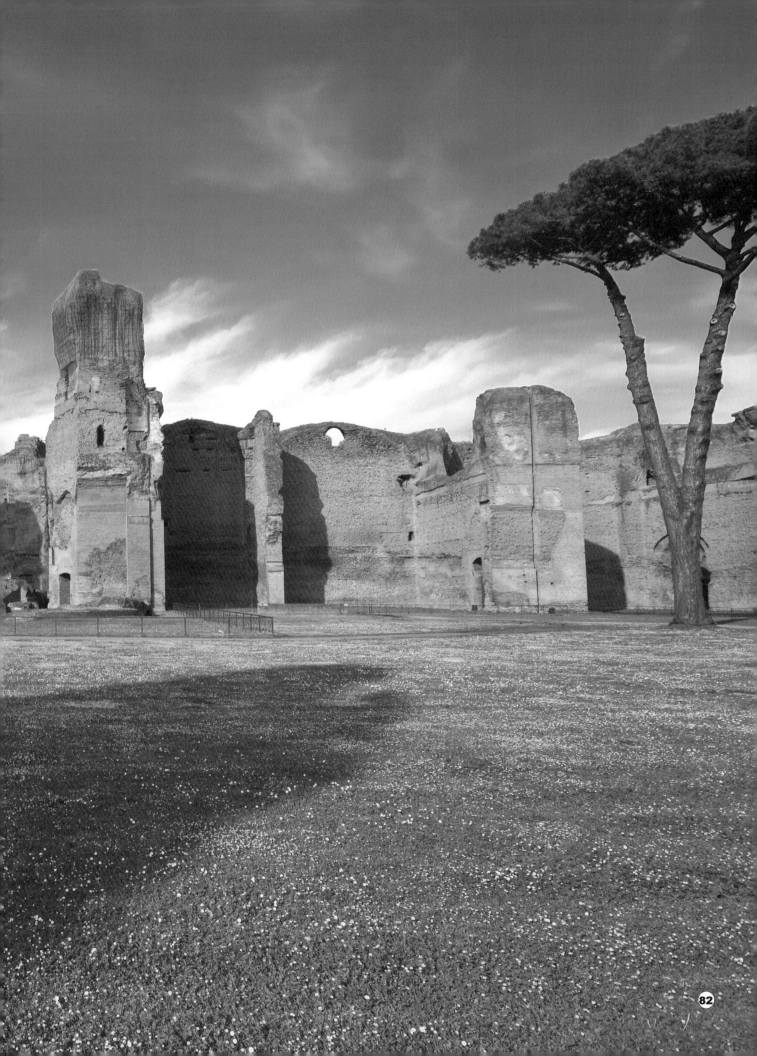

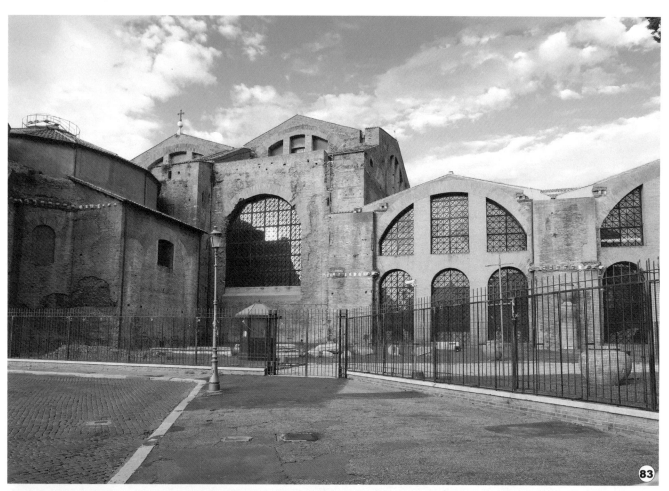

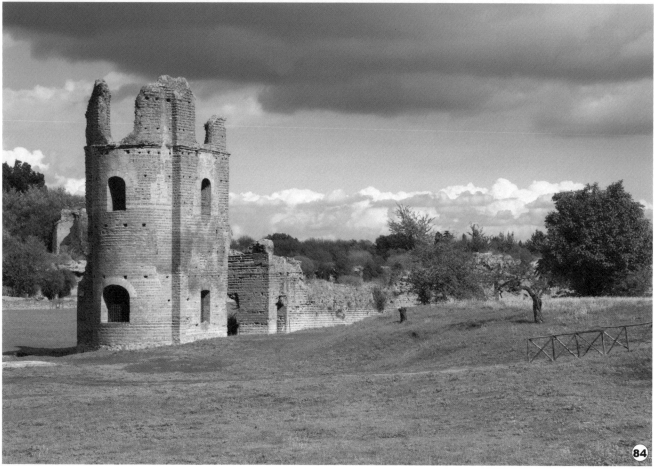

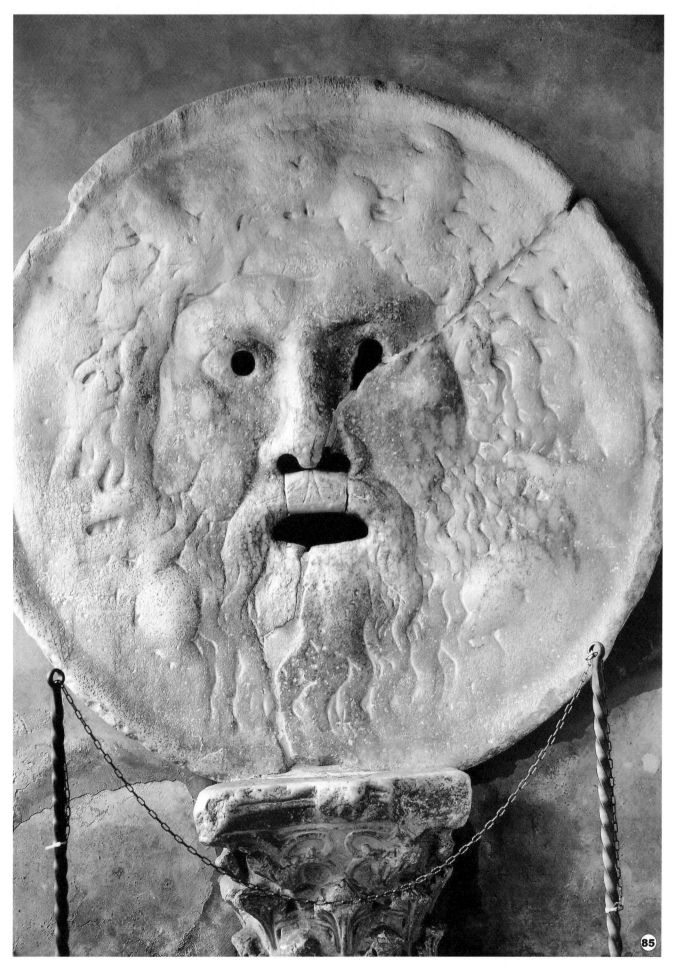

85

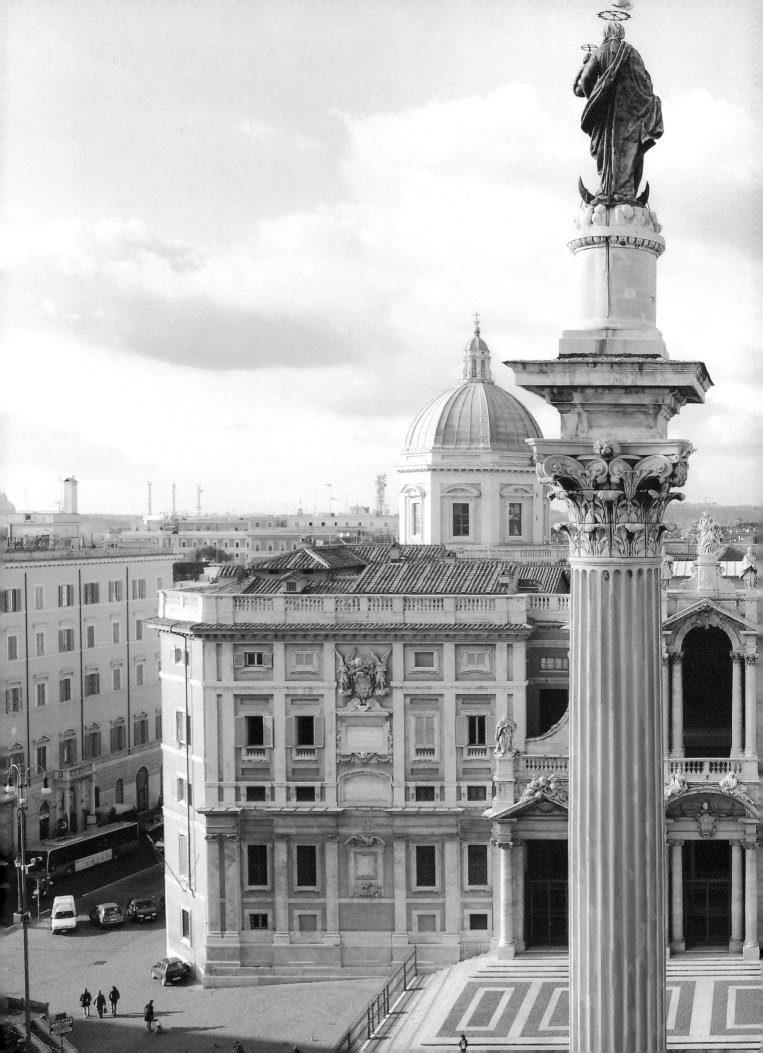

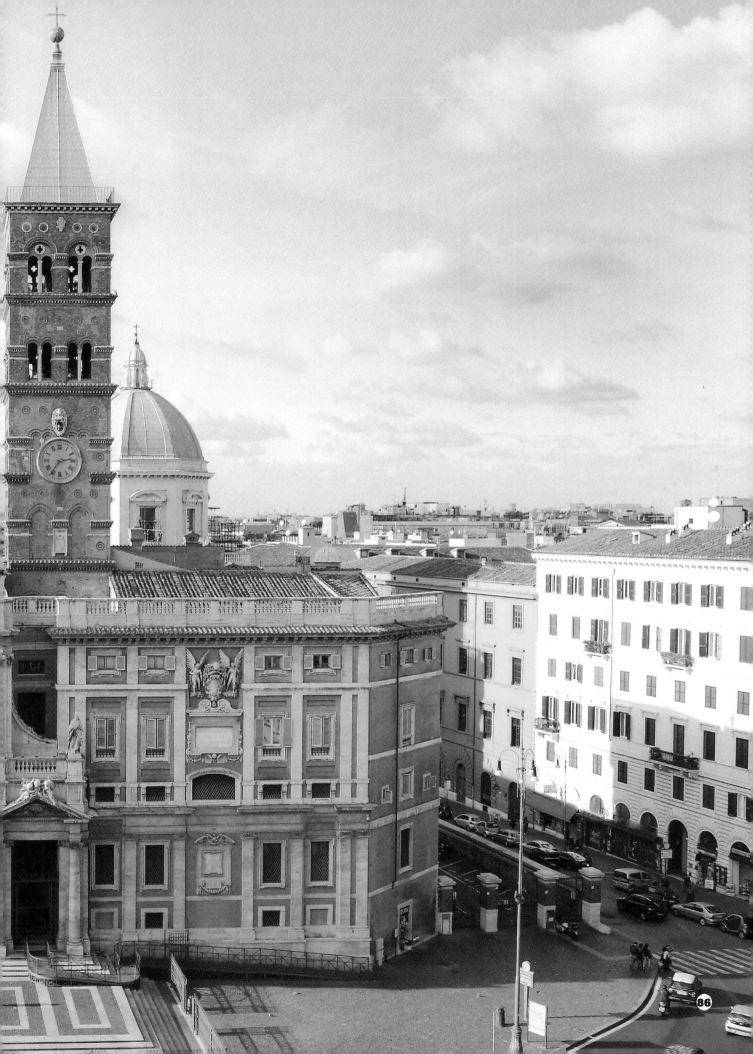

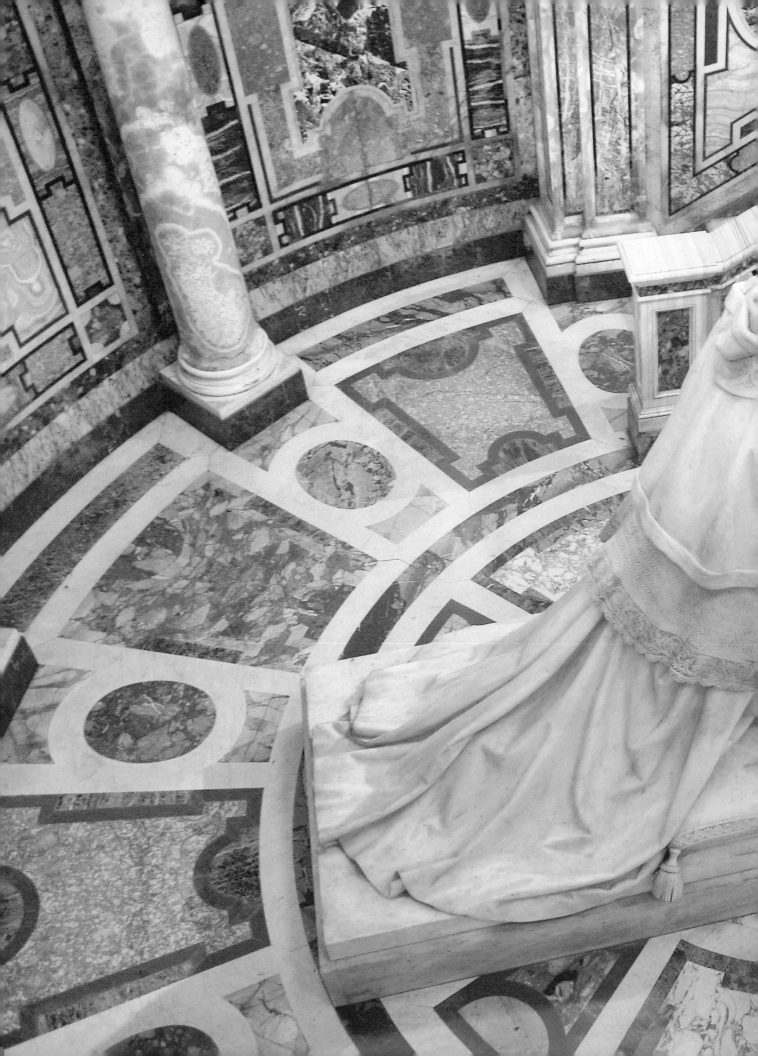

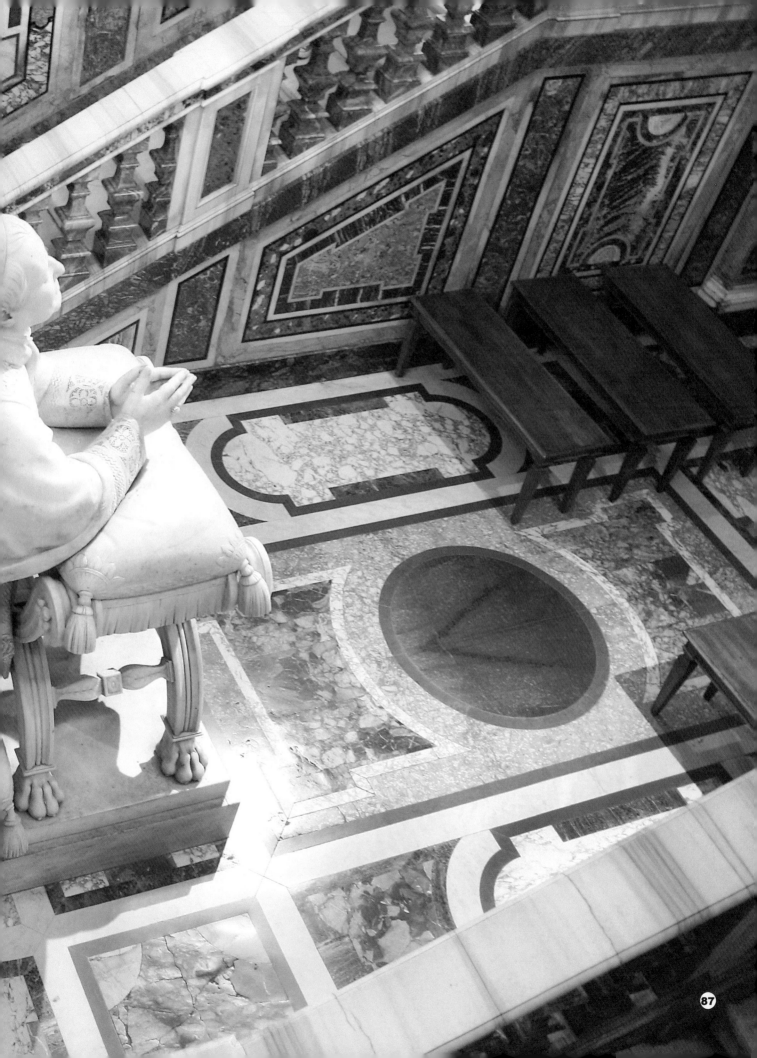

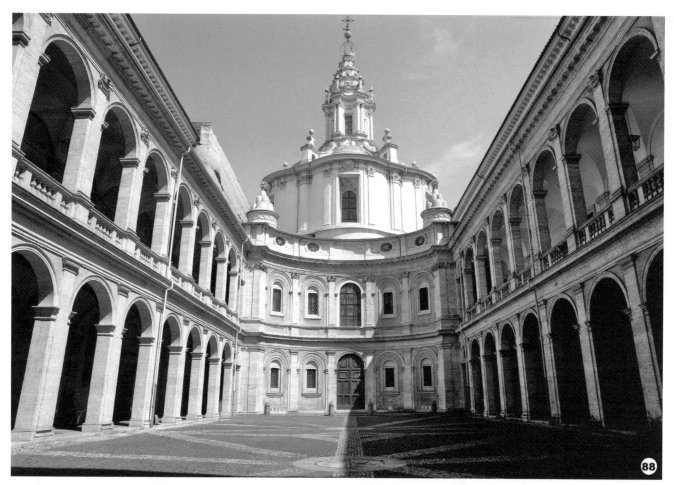

Speaking of ancient Rome, we must mention the Circus of Maxentius (Circo di Massenzio, photo 84), one of the best-preserved Roman circuses, finished in 312 A.D. Although it was the second largest circus in the Empire, most likely it was never used after the death of Maxentius, in 312.

Dating from the ancient times, probably from the 4th century B.C., is the famous sculpture named Bocca della Verita (the mouth of truth, photo 85). The legend states that if one puts his hand in the mouth of the statue and tells a lie, the mouth will bite the hand off.

The city of Rome is home to a multitude of beautiful churches. The largest Roman Catholic church in Rome is Saint Mary Major (Basilica di Santa Maria Maggiore, photo 86). The present church, built under Pope Sixtus III (432-440 A.D.) became a papal basilica. Even today, the Pope uses it for occasions, including the feast of the Assumption of Mary on 15 August.

Inside Basilica di Santa Maria Maggiore, there are many amazing works of art such as 5th century mosaics, beautiful crypts or the statue of Pope Pius IX (photo 87).

Another popular Roman Catholic church in Rome is the Church of Saint Yves at La Sapienza (Chiesa di Sant'Ivo alla Sapienza, photo 88), built between 1642 and 1660. Located centrally between Piazza Navona and the Pantheon, it is a marvelous example of Roman Baroque architecture.

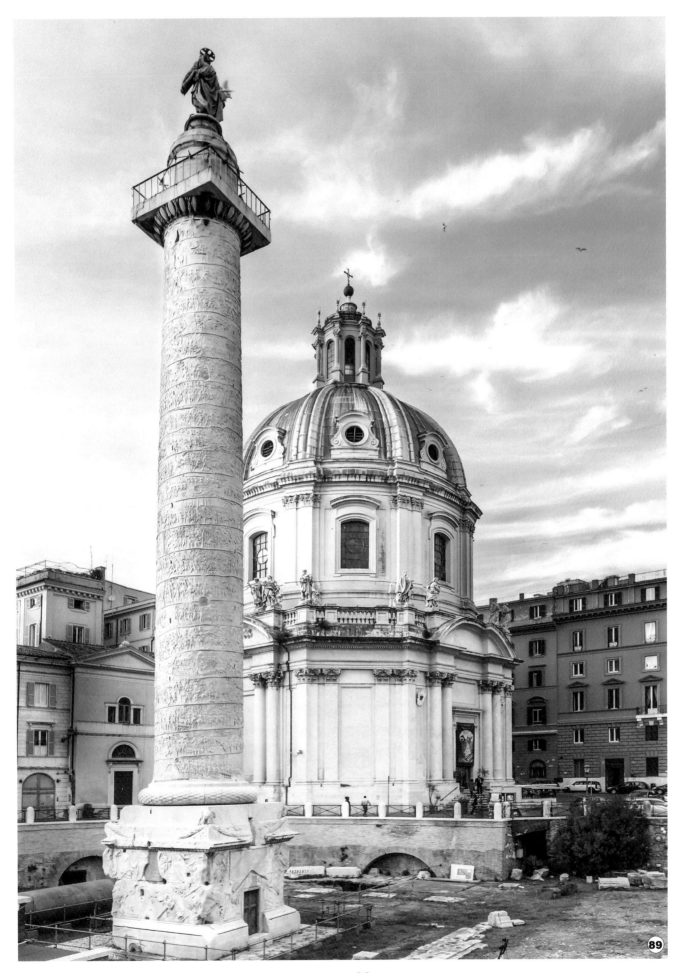

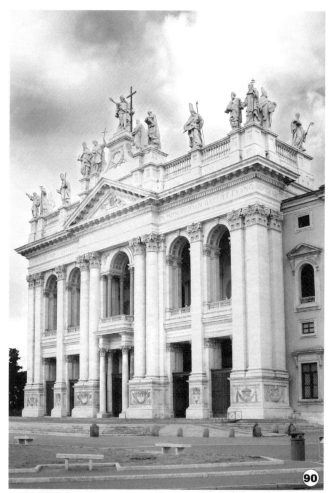

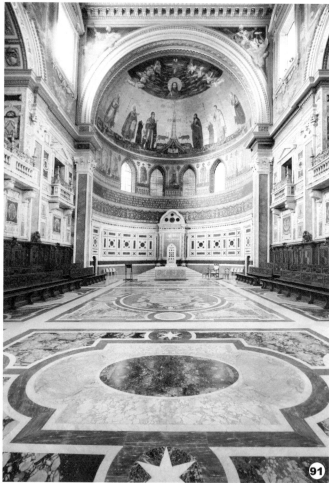

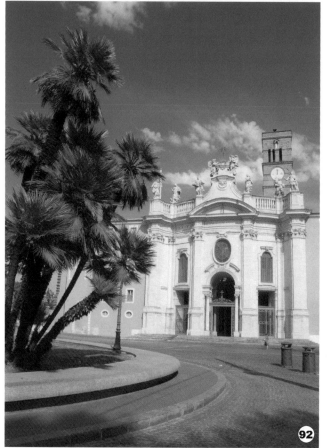

Just across the street from Trajan's Forum is the church of Saint Mary of Loreto (Santa Maria di Loreto). Jacopo del Duca, one of Michelangelo's students, built it in 1573 with a picturesque dome inside (photo 89).

The Papal Basilica of Saint John Lateran (San Giovanni in Laterano) is the official cathedral and thus the ecclesiastical seat of the Pope (photo 90). The interior is beautifully decorated in the cosmatesque style, typical in medieval Italy (photo 91).

Some churches in Rome are home to holy relics, such as the passion relics inside the church of the Holy Cross in Jerusalem (Santa Croce in Gerusalemme, photo 92), which include objects like fragments from the cross on which Jesus Christ was crucified or thorns from his crown.

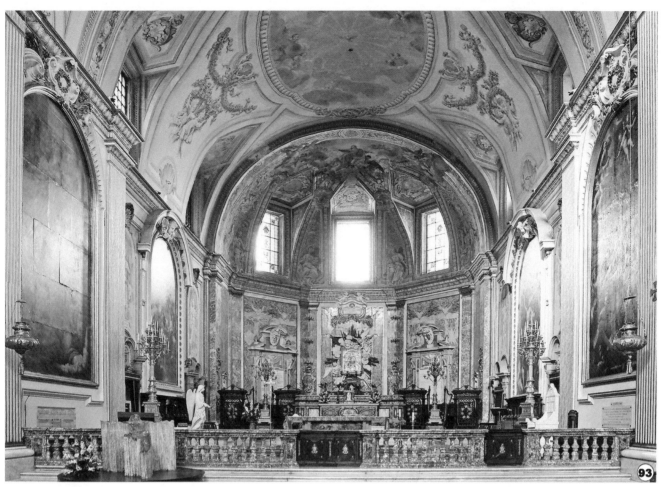

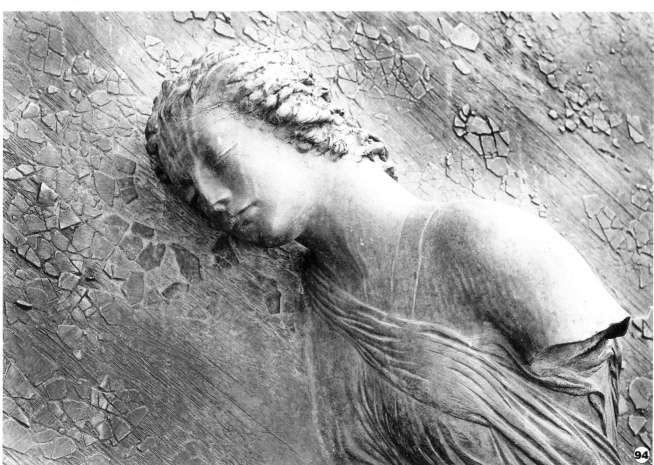

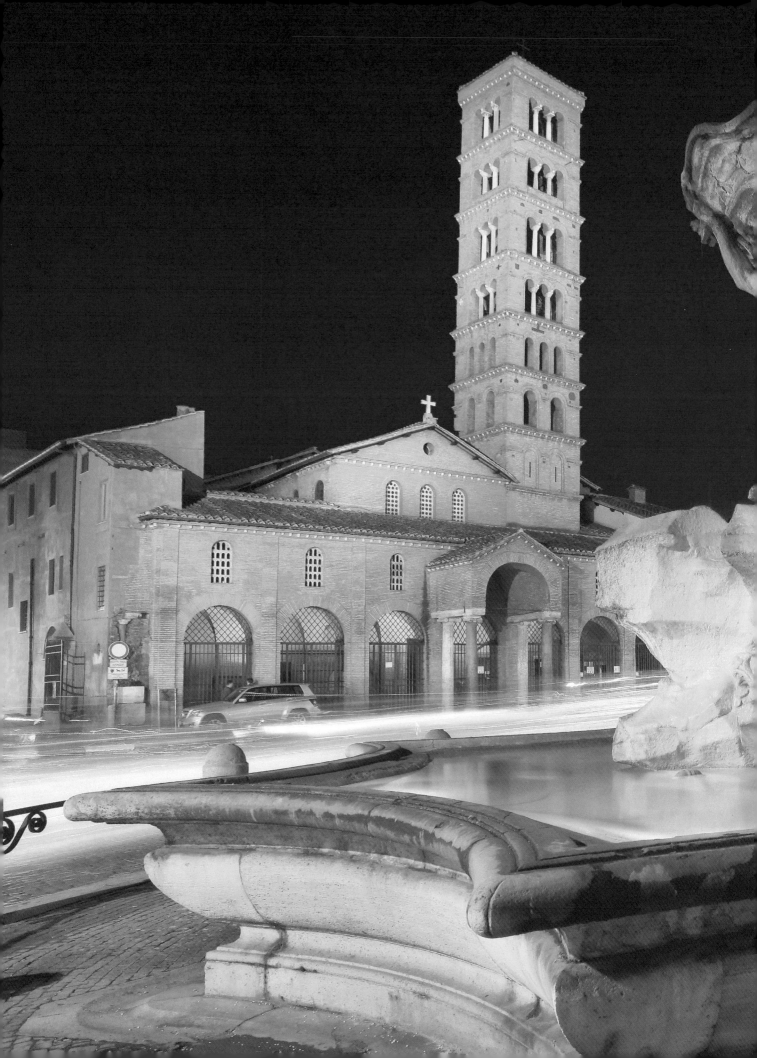

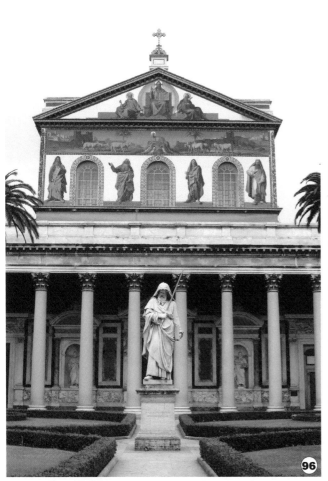

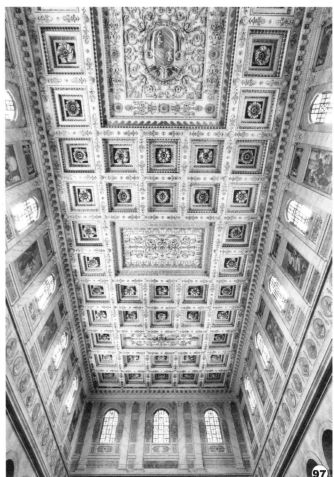

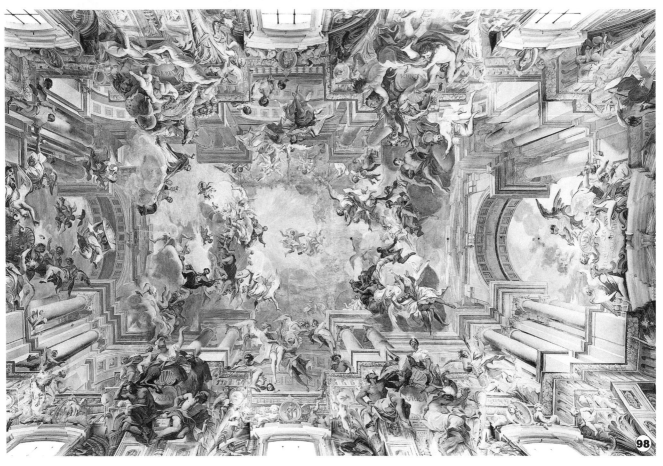

68

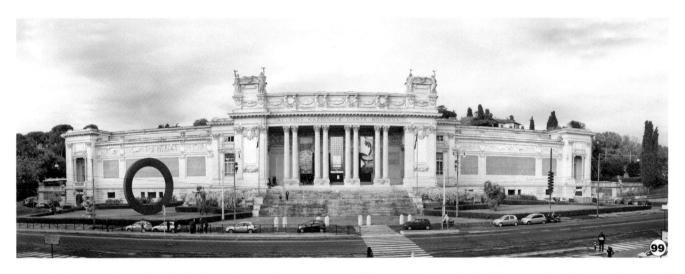

Inside the Baths of Diocletian there is now a well-known church in Rome: Santa Maria degli Angeli e dei Martiri (photo 93). The bronze door of the church, created in 2006, has beautiful statues created by the Polish-born sculptor Igor Mitoraj (photo 94).

One of the most interesting places of worship in Rome is the church of Saint Mary in Cosmedin (Basilica di Santa Maria in Cosmedin). Dating from the 8th century, this church has a medieval crypt, historical artworks and enshrines the relics of Saint Valentine (photo 95).

The Church of of Saint Paul Outside the Walls (Basilica San Paolo Fuori le Mura) is one of the pilgrimage churches, central to a religious pilgrimage to the city (photo 96). The interior of the church has 80 columns, 5th century mosaics on the triumphal arch, scenes from Saint Paul's life and a gold-coffered ceiling (photo 97).

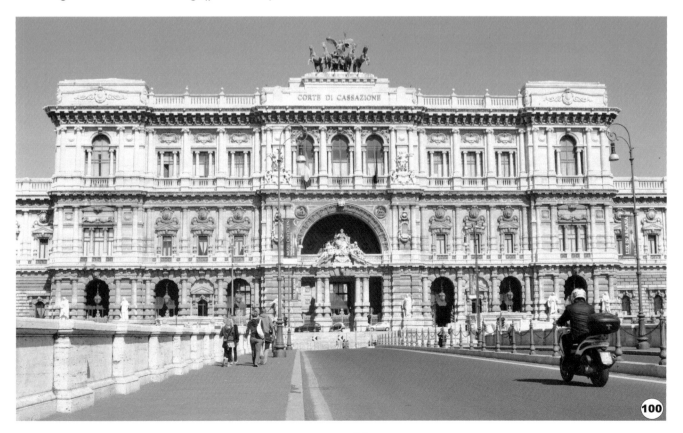

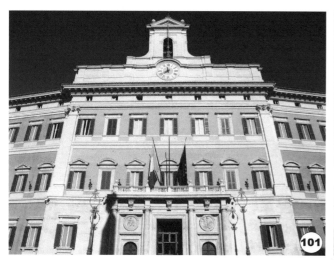

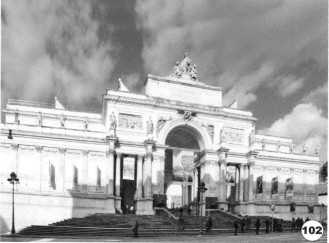

The church of St. Ignatius of Loyola is home to the extravagant fresco of Andrea Pozzo, a wonderful work of art stretching across the nave ceiling (photo 98).

One of Rome's features is the abundance of elegant buildings, palaces and villas. Such an impressive building is the National Gallery of Modern and Contemporary Art (photo 99), created by Cesare Bazzani at the beginning of the 20th century.

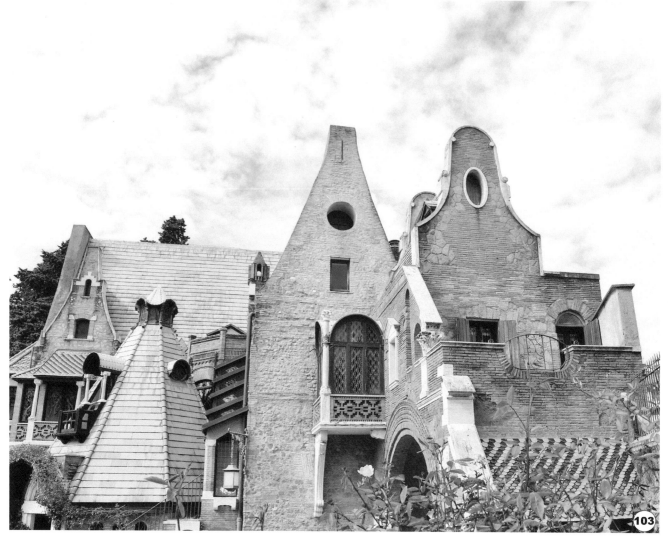

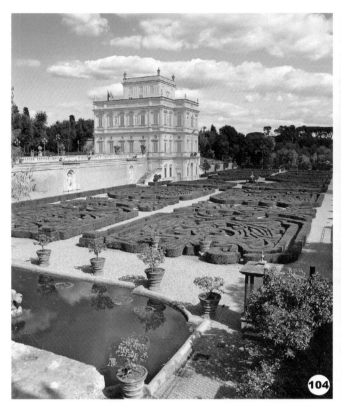

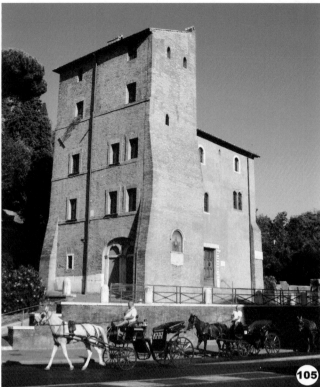

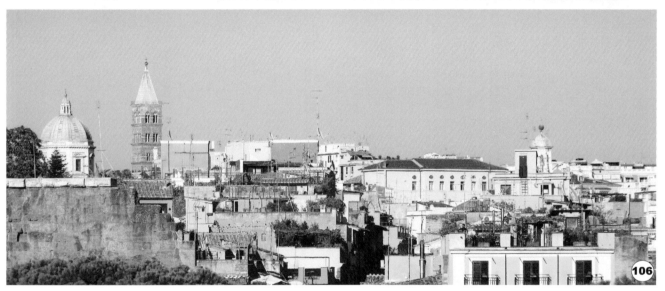

The Palace of Justice (Palazzo di Giusitzia), the seat of the Supreme Court of Cassation, is considered one of the grandest buildings in Rome's recent history. It was built between 1888 and 1910, and its architecture has Baroque and late Renaissance influences (photo 100).

Montecitorio Palace (Palazzo Montecitorio) is an elegant building from the 17th century, now the seat of the Chamber of Deputies. The government redesigned the palace at the beginning of the 20th century, leaving only the facade unchanged (photo 101).

The Palace of Expositions (Palazzo delle Esposizioni), is an impressive neoclassical building used as an exposition hall and cultural center. Opened in 1883, it now has a cinema, a restaurant, a museum and a library (photo 102).

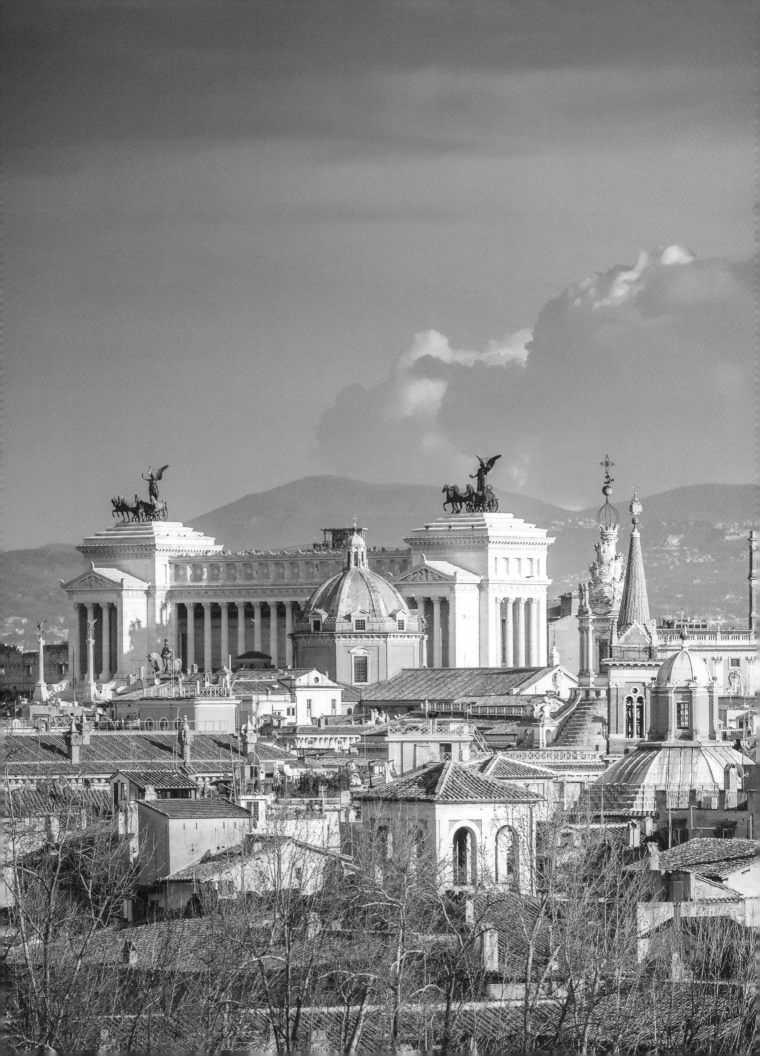

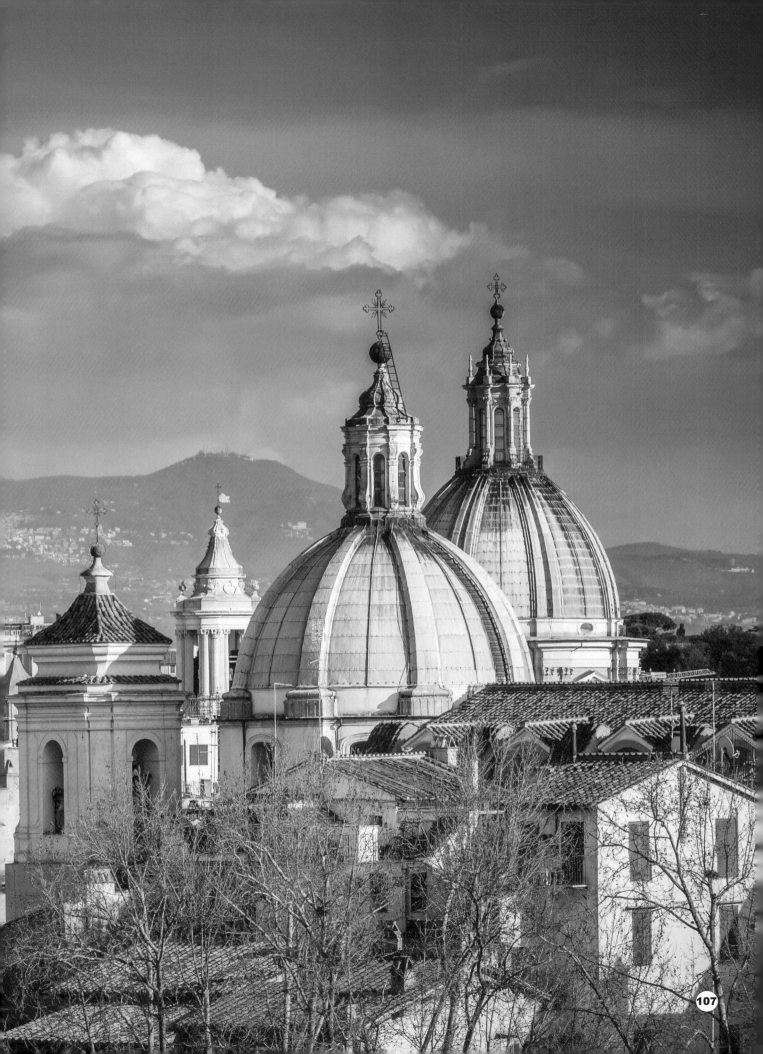

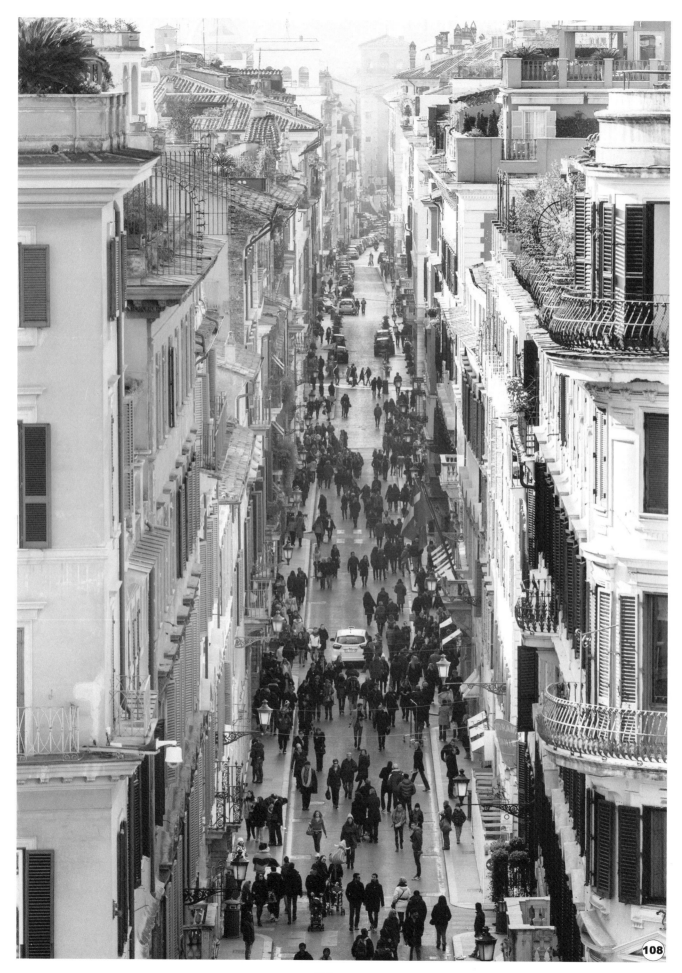

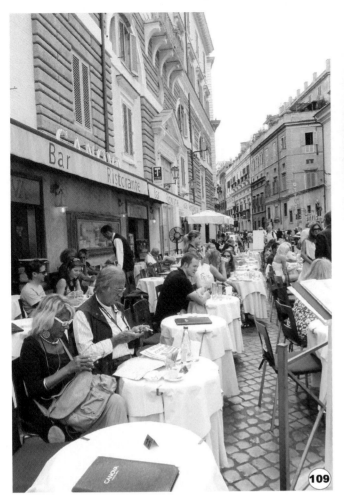

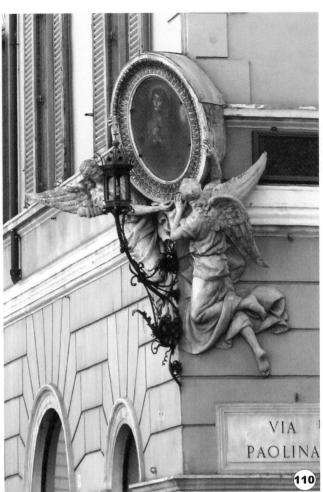

Around Rome there are many villas usually surrounded by gardens or parks. Many of these villas were home to powerful, historic families that lived in Rome over the past centuries. An example is the House of the Owls (Casina delle Civette, photo 103) from Villa Torlonia, designed in 1840.

In the quarter of Monteverde, there is another architectural beauty: Villa Doria Pamphili. This was the property of the rich Pamphili family and the "old villa" dates back to 1630 (photo 104).

A walk thought the streets of Rome is enough to reveal the romantic aspect of this city. Better yet, a tour with a horse carriage is an unforgettable experience (photo 105).

Rome, built on several hills, gives the traveler the opportunity to admire the colors and the roofs of the city from a high point of view (photo 106). At sunset the view can be really breathtaking (photo 107)!

The city center, packed with shops and visitors, buzzes with activity, especially in the summer. Condotti street (Via Condotti), located in front of the Spanish Steps, is one of the busiest and more fashionable streets in Rome (photo 108).

Between landmarks and shops there are small, narrow streets where tourists can always find a place to relax, eat or drink (photo 109).

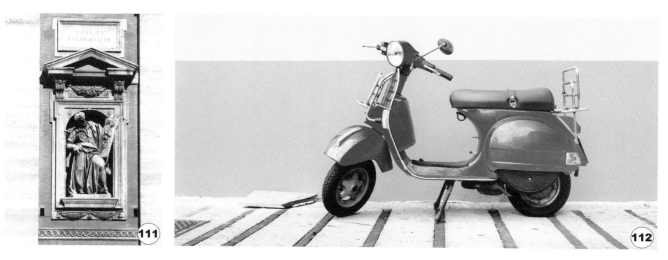

In Rome, art is all around the city, from the stained windows of old buildings to sculptures of angels and saints hidden among narrow streets (photos 110 and 111).

Tourists can see one of the urban symbols of Rome, the classical and popular motor scooter, at every corner (photo 112).

Secret, peaceful places are waiting for someone to discover them in the labyrinth of the old city's streets (photo 113).

Street performers entertain the traveler around the city. They are often found in public squares and around popular areas (photo 114).

Beautiful windows packed with flowers faithfully reflect the city's vivid colors (photo 115).

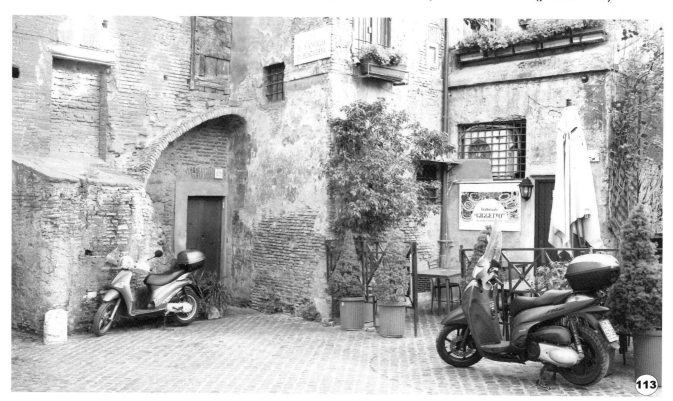

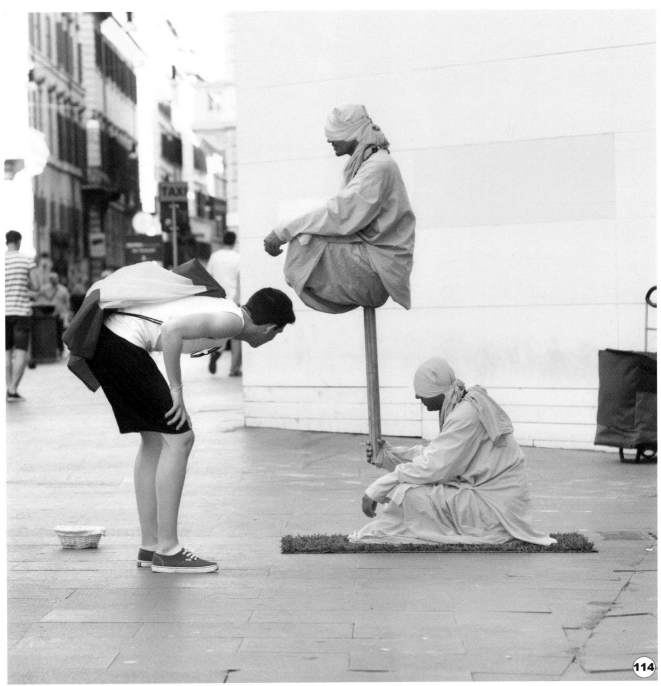

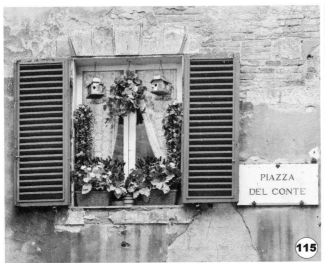

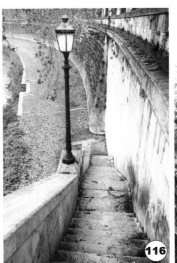

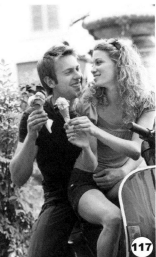

77

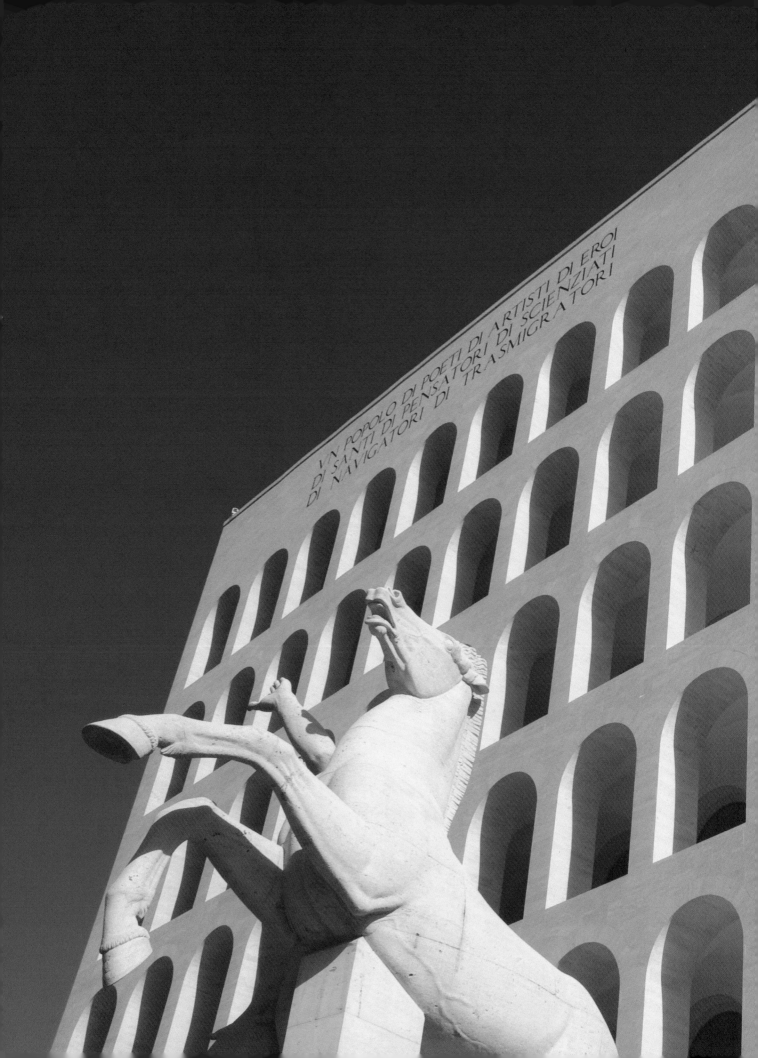

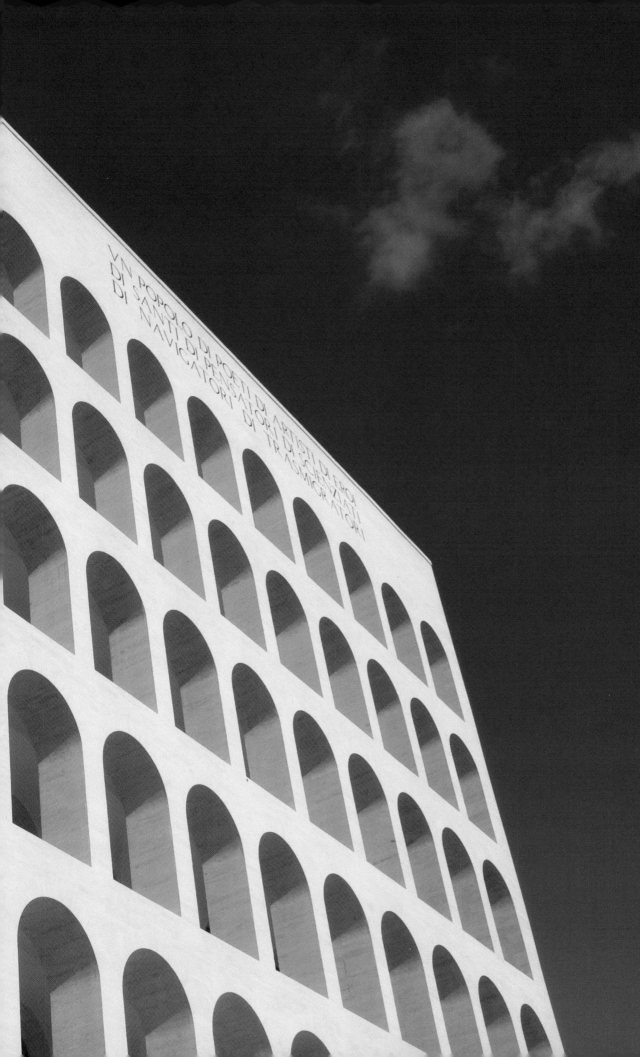

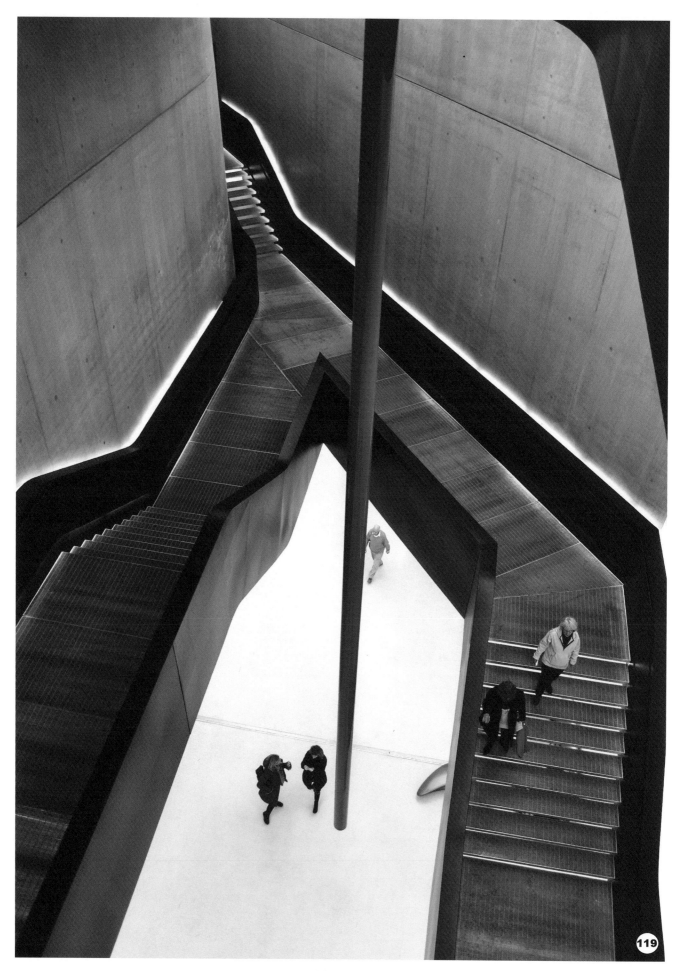

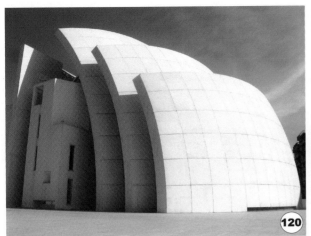

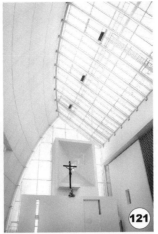

A trip to Rome is not complete without a stroll on the banks of the river Tiber (photo 116), and of course, when in Rome, tasting the gelato the original Italian ice cream, is a highly recommended experience (photo 117).

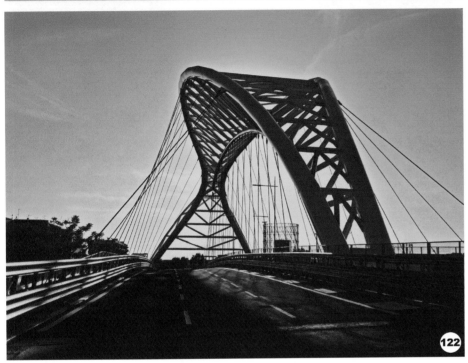

Rome is a city with a millennia-old history, but this does not mean it lacks modernity. Palazzo della Civiltà Italiana (Palazzo della Civiltà del Lavoro) was part of a complex built for the 1942 world exhibition. It is a typical example of monumental Fascist architecture (photo 118).

One marvelous example of contemporary architecture is Museo Nazionale delle Arti del XXI Secolo (MAXXI museum), inaugurated in 2010 (photo 119).

Many believe the Jubilee Church (Chiesa di Dio Padre Misericordioso, photo 120), located in Tor Tre Este district, is one of the finest contemporary churches in Rome. Natural light cascades down from the glass roof into the interior, creating a mystical sensation (photo 121).

The Ostiense Bridge (Ponte Ostiense), opened in 2012, completes the modern side of Rome, and bears the nickname "the Cobra" due to its look (photo 122).

Rome, the "eternal" city is one of the most interesting travel destinations in the world. It has everything from ancient monuments to medieval art and modern architecture. One trip to Rome is something that should be on everyone's "to do" list because the spirit, the feeling, and the memories of this city will last for a lifetime!

List of contributing photographers

List of contributing photographers

List of contributing photographers

List of contributing photographers

Angel sculptures on street corner. © Alexandru Ciobanu – photo 110, page 75

Saint Lucas on a street in Rome. © Alexandru Ciobanu – photo 111, page 76

Motor scooter. © Alexandru Ciobanu – photo 112, page 76

Amazing courtyard in Rome. © Konstantinos Papaioannou, Dreamstime – photo 113, page 76

Fakirs. © Habrda, Dreamstime – photo 114, page 77

Window with hatches and flowers in Rome. © Pwollinga, Canstockphoto – photo 115, page 77

Staircase and street Lamp. © Kvkirillov, Canstockphoto – photo 116, page 77

Coppia con gelato. © Roberto Serratore, Fotolia – photo 117, page 77

Mussolini time architecture building in Rome, Italy. © 300pixel, Canstockphoto – photo 118, pages 78-79

Maxxi Museum In Rome. © Enricodevita, Bigstockphoto – photo 119, page 80

Jubilee Church. © Brian Eagen, Dreamstime – photo 120, page 81

Chiesa delle Vele – Interno. © Stefano Gruppo, Fotolia – photo 121, page 81

Garbatella's Bridge, Rome, Italy. © Marcorubino, Canstockphoto – photo 122, page 81.

ROME
A PHOTOGRAPHIC TOUR

122 AMAZING PHOTOS

From the series Photographic Tours.

First Edition

ISBN-13: 978-973-0-19085-4

alexandru.ciobanu.books@gmail.com

www.alexandru-ciobanu.com
www.alexandruciobanubooks.wordpress.com

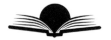

CPSIA information can be obtained at www.ICGtesting.com
Printed in the USA
BVIW12n2356020116
431503BV00011B/47

* 9 7 8 9 7 3 0 1 9 0 8 5 4 *